PUEBLO POTTERY DESIGNS

KENNETH M. CHAPMAN

Dover Publications, Inc., New York

Published in Canada by General Publishing Company, Ltd., 30 Lesmill Road, Don Mills, Toronto, Ontario.

Published in the United Kingdom by Constable and Company, Ltd., 3 The Lanchesters, 162–164 Fulham Palace Road, London W6 9ER.

Bibliographical Note

This Dover edition, first published in 1995, is an unabridged republication of the second revised printing of *The Pottery of Santo Domingo Pueblo: A Detailed Study of Its Decoration,* Memoirs of the Laboratory of Anthropology, Volume I, published in 1953 at the University of New Mexico, Santa Fé. Some of the plates have been rearranged for this edition.

DOVER *Pictorial Archive* SERIES

Library of Congress Cataloging-in-Publication Data

Chapman, Kenneth Milton, 1875–1968.
 [Pottery of Santo Domingo pueblo]
 Pueblo pottery designs / Kenneth M. Chapman.
 p. cm. — (Dover pictorial archive series)
 . . . an unabridged republication of the second revised printing of The pottery of Santo Domingo pueblo: a detailed study of its decoration, published in 1953 by the Laboratory of Anthropology, the University of New Mexico, Santa Fé.
 Includes bibliographical references.
 ISBN 0-486-28476-X
 1. Pueblo pottery—New Mexico—Santo Domingo Pueblo—Themes, motives. 2. Pueblo pottery—New Mexico—Santo Domingo Pueblo—Classification. 3. Santo Domingo Pueblo (N.M.)—Antiquities. I. Title. II. Series.
E99.P9C47 1995
978.9'57—dc20
 94-41764
 CIP

Manufactured in the United States of America
Dover Publications, Inc., 31 East 2nd Street, Mineola, N.Y. 11501

TABLE OF CONTENTS

TABLE OF CONTENTS

LIST OF ILLUSTRATIONS

TEXT FIGURES

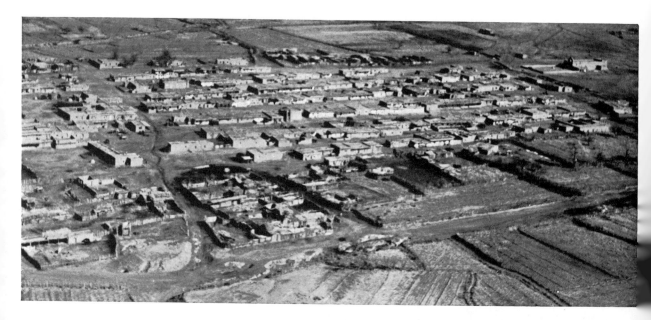

THE PUEBLO OF SANTO DOMINGO FROM THE AIR, LOOKING NORTH
(Courtesy of New Mexico Magazine)

FOREWORD

The pottery of the prehistoric pueblos of the American Southwest has long been known as one of the most remarkable aboriginal crafts ever developed in the New World. Extensive excavations during many years have yielded thousands of specimens which, displayed in many museums of our country, present a wealth of source material for the study of form and design.

During the past fifty years such emphasis has been placed upon the recovery of these buried treasures that but scant attention has been given to the equally valuable sources of design to be found in the pottery of the pueblos which have survived the Spanish conquest and are carrying on today as in centuries past. Doubtless it was the lure of the unknown that has prompted so much digging, but if the archaeologists had only realized that the rarest of all Pueblo pottery is that of the two centuries following the Conquest, they might have diverted at least a part of their energy to ferreting out the remnants of the antique ceramics of each pueblo.

Lack of interest in the more recent wares may have been due also to the wide variance between the pre-Spanish and the modern, which led casual observers to assume that the marked changes in style were largely the result of contact with the invaders. The fallacy has been exposed in recent years, for Pueblo pottery of the past three centuries seems to have undergone a normal development, with scarcely a trace of borrowing from the decorative motifs of Spanish crafts.

When museums finally turned their attention to the pottery of the surviving pueblos, naturally the more ornate and colorful wares of the Tsia, Acoma, Zuñi, and Hopi potters were eagerly sought, while the pottery of the Rio Grande pueblos, of technique less refined and showy, was neglected. Yet the remarkable decorative effects achieved with a paucity of motifs and a certain crudity of technique give them a peculiar value in design as important in many respects as that of the comparatively sophisticated wares of the more western pueblos. Of the Rio Grande wares, that of Santo Domingo pueblo is one of the least known.

The study of the decorative art of Santo Domingo pottery, embraced in this monograph, although begun in the year 1920, has been carried on principally during the past four years. While undertaken with some assurance of prompt publication, it soon became apparent that the project would require considerable research and access to much more material than that available at the outset. A brief account of the circumstances leading to it is worthy of record since it throws light upon the difficulties encountered by myself and by others in carrying on research in a field which was then so little known.

A residence of more than thirty-five years in New Mexico has given me unusual opportunities of observing many changes in the ceramic art of the Pueblo

Indians. But one needs only to launch into such a study as this to realize fully how superficial can be one's observations of any craft, when made during casual trips to the pueblos where so many other phases of culture claim the attention of visitors.

In 1909 I joined the staff of the newly organized Museum of New Mexico, under the direction of the School of American Archaeology[1] in Santa Fé, and for the following twenty years participated in the development of the new institution. From its inception the activities of the School were directed almost entirely toward the accumulation and study of archaeological material from excavations, and this program was clearly reflected in the character of exhibits maintained in the Museum. During this period, my part time duties successively as Secretary, Assistant Director, Curator, and Associate in various departments, gave scant opportunity for even casual visits to the neighboring pueblos, and permitted no field work outside the various camps where archaeological excavations were in progress.

Satisfactory though such work had been, I became more and more impressed, through succeeding years, with the fact that the antique pottery and other crafts of the living pueblos were fast disappearing, and that one or more of the museums of our country could well afford to curtail, or even abandon for a time, their programs of excavation in order to divert funds for collecting the surviving culture material of the Pueblo Indians.

Finally, in 1920, I determined to undertake a survey of the conditions then existing in the nearby pueblos, and to enter upon a thorough study of the decorative art of one or more of them. Having obtained permission from my institution to devote at least one-half of my time to such a project, I chose the ceramic decoration of Santo Domingo because of its comparative simplicity and of the relative abundance of material still available at that pueblo. As the arrangement included no funds for field work I found it necessary to begin with the Santo Domingo pottery then available in Santa Fé.

The only museum collection of Pueblo pottery of the post-Spanish period was that of the New Mexico Historical Society, housed by the Museum of New Mexico, in the Palace of the Governors. This, acquired in large part prior to 1900, though comparatively rich in specimens from the more remote pueblos of Tsia, Acoma, and Zuñi, contained but three from nearby Santo Domingo. It emphasized the fact that but scant attention had been paid to the wealth of material from the pueblos near at hand.

The outlook would have been discouraging indeed, but for the fact that dealers in antiques had been acquiring pottery in considerable quantities for sale to museums and tourists. The study of such material coming into the shops required prompt action, for it was readily sold, and once it left Santa Fé much of it could never be seen again.

In my earliest visits to Santo Domingo pueblo, made between the years 1900 and 1909, I was impressed with the relative integrity and simplicity of the decorative art in the abundant supply of pottery then in general domestic use. My pre-

[1] Known since 1917 as the School of American Research.

liminary sketches of pottery designs acquired during those years had naturally been somewhat haphazard—made as they were during random visits to the pueblos, and for no definite future use. My systematic study of the decorative art of Santo Domingo pottery began therefore with a complete photographic record of specimens from which many of the accompanying designs were copied. While I did not use the full time permitted me for this work, I gave considerable attention during the next three years to photographing specimens from all the pueblos and to copying the designs from Santo Domingo ware.

The year 1923 saw the beginning of a movement of great importance in the preservation of the fast disappearing crafts of the Pueblos. A small group composed largely of residents of Santa Fé, impressed with the need of prompt and vigorous action in order to save the arts of the Southwestern tribes for future generations of craftsmen, contributed specimens from their own private collections of pottery to form the nucleus of a projected museum collection, and to further its growth effected an organization first known as the Pueblo Pottery Fund. From this small beginning, through donations of specimens and funds from memberships, the collection grew with great rapidity until the close of 1925 when the importance of the enterprise warranted its incorporation as the Indian Arts Fund. As interest and support for the Fund developed, it was soon apparent that a surprising amount of antique pottery still remained in the homes of Pueblo Indians and that it could be acquired at prices which, although notably higher than those of earlier days, were absurdly low as compared with the values set by dealers for comparable material from other cultures. It seemed best then to defer completion of this work upon the pottery of Santo Domingo and other nearby pueblos until a fully representative collection from each could be obtained. Concentration upon this one task won ever increasing financial support which, beginning with 1926, provided for systematic collecting tours to many of the pueblos. The field work was continued after 1929 by the newly organized Laboratory of Anthropology, in coöperation with this and other activities of the Indian Arts Fund, and the superb collection of over 2000 specimens now owned and exhibited jointly by the two organizations constitutes a monument to the zeal of all who have had a part in its assemblage. By 1930 the acquisition of specimens began to decline at a noticeable rate for but little of value remained in any of the pueblos. To this difficulty was added another, and that particularly in the pueblo of Santo Domingo. Open, and too vigorous efforts at collecting antique pottery had so displeased the elders of the pueblo that they began to use every means of prohibiting its sale. Under these circumstances the combined organizations began to concentrate upon the collection of other arts. With the resulting stabilization of the pottery collection, which now included a great number of specimens of Santo Domingo ware, I felt that the time had come at last, to resume the study of my Santo Domingo material. This I took up again in 1931, as a project under the Laboratory of Anthropology, and by the close of 1932 I began to arrange it in its present form.

The greater part of the photographs used in Plates 1 to 6, inclusive, are from

specimens in the collection of the Indian Arts Fund. Approximately one-third of the drawings for the plates were made during my connection with the School of American Research and Museum of New Mexico, and the greater part of these are authenticated by photographs of the specimens from which the drawings were made. These, with the many others taken from specimens in the collection of the Indian Arts Fund, constitute more than two-thirds the drawings used. The balance, or approximately 300, were drawn from sketches, made when and where photographs could not be secured. In assembling the drawings, practically the entire available mass of material has been used, regardless of my personal views as to the relative importance of some of the minor variants of certain motifs. The thirty-four figures included in the text are from my drawings.

ACKNOWLEDGMENTS

The School of American Research and the Museum of New Mexico made possible the initial phases of this study, and have also given their generous permission for the inclusion of that important part of the work in this volume.

Dr. A. V. Kidder has given his fullest encouragement to the project from its inception. His enduring interest in its progress throughout these many years has helped immeasurably in bringing it to completion.

The American Museum of Natural History, Field Museum of Natural History, Peabody Museum of Archaeology and Ethnology, San Diego Museum, United States National Museum, and other institutions have afforded facilities for the study of their collections. The Fred Harvey Company, Southwest Arts and Crafts, Spanish and Indian Trading Company, Thunderbird Shop, Mr. J. S. Candelario, and others have also aided greatly in placing material at my disposal.

Under the pressure of other duties, the work would have lagged much longer, without the invaluable assistance of several individuals who have contributed most generously of their time in the preparation of drawings. Of these, Miss Anna O. Shepard provided more than 300, while many others were made by Miss Miriam Marmon, Miss Margaret W. Blecha, and Miss Beula M. Wadsworth.

Publication is made possible by a grant to the Laboratory of Anthropology, from the Carnegie Corporation of New York, administered by the Carnegie Institution of Washington.

It is with great pleasure that I record here my deep indebtedness to all these and to many others who have aided in various ways in the completion of this first inclusive study of the ceramic decoration of any modern pueblo.

THE PUEBLO OF SANTO DOMINGO

The pueblo of Santo Domingo is an Indian village of Keresan linguistic stock, situated upon the east bank of the Rio Grande, some thirty miles southwest of Santa Fé, New Mexico. With a population of nearly 1000, it is the largest of five Keres pueblos of the Rio Grande group. Two of these, Cochiti, seven miles to the northwest; and San Felipe, twelve miles to the southwest, lie in the Rio Grande valley proper; while Santa Ana and Tsia are situated somewhat farther west, upon the Jemez river, a western tributary of the Rio Grande. Still farther southwest are the Western Keres pueblos of Laguna and Acoma, two important and populous communities, each with its subordinate villages. Immediately outlying the Rio Grande Keres groups are ten pueblos of Tigua, Tewa, and Jemez-Pecos lin-

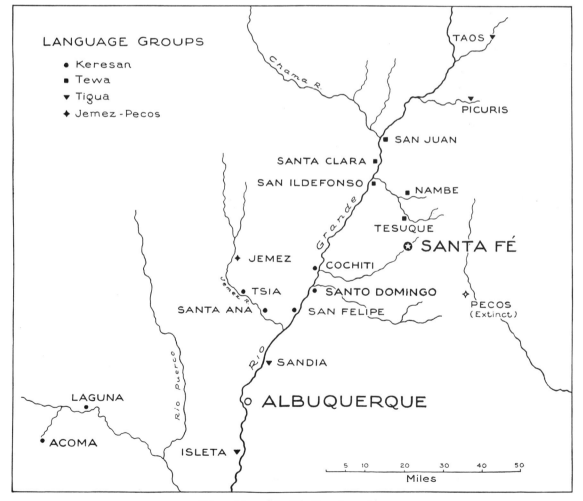

FIG. 1—Map of the Rio Grande pueblos.

guistic groups. Formerly there were several important Tano pueblos to the east
of Santo Domingo, as well as the thriving pueblo of Pecos, which was not aban-
doned until 1838.

Within this complex of villages of four surviving language groups, Santo
Domingo has held its own since the days of Coronado, in spite of disastrous floods
which have compelled the abandonment of several successive sites. The last of
these, in 1886, washed away a considerable part of the old pueblo, with its ancient
mission, and led to the extension of the present village to the east, with its com-
paratively wide, straight streets between solid rows of one, and occasionally two,
storied houses of adobe.

Santo Domingo has long been known as one of the most conservative of all the
pueblos. Although situated near the old Spanish highway between Santa Fé and
Mexico, her people have held themselves aloof, within the boundaries of their
land grant of nearly 75,000 acres, received from the Spanish crown in 1689 and
confirmed by act of Congress in 1858. In more recent years they have been forced
into closer contact with their white neighbors. In 1881, the building of a railroad
within a quarter-mile of the pueblo aroused the resentment of the elders who
have since objected strenuously and consistently to the location of a Government
school, the digging of wells, and every successive innovation of the Indian Service.
While this policy of aloofness is relaxed during their principal feast days, only the
purchase of pottery or other products now gives visitors freedom of the village for
more than the briefest of visits and with the relocation of the new transcontinental
highway five miles to the eastward, the potters are now urged to sell their wares
there as a further means of discouraging visits of tourists to the pueblo. Under
these circumstances the conduct of investigations of any nature has been well nigh
impossible at Santo Domingo, without secrecy and the attendant risk of involving
well meaning informants in most serious difficulties.

THE
POTTERY OF SANTO DOMINGO PUEBLO

Pottery making, since early prehistoric times the principal craft of women in all the pueblos, has survived at Santo Domingo, where such utensils for domestic service are still much in evidence. The primitive materials, tools and techniques are still those used for untold centuries before the coming of the Spaniards, for the potter's wheel, the permanent kiln, and other devices of the white man have never found a foothold in Pueblo land.

ANTECEDENT POTTERY TYPES

The wiping out of certain ancestral sites of the Santo Domingo people by floods, and the prohibition of excavation in others, have made it impossible to obtain examples of the types of pottery in use in pre-Spanish and early post-Spanish times. Since no specimens, other than a few sherds, of such early wares have been obtained at the present site, the following definitions of types and the accompanying illustrations (fig. 2) are based upon representative specimens from other sources within, or immediately adjoining the Keres area. These are given in the order of their chronological sequence.

1. BLACK-ON-WHITE WARE[1] (circa A. D. 1000-1400), of comparatively hard paste with decoration in a more or less greyish black on a whitish or greyish slip. Bowls (fig. 2, *a*), averaging 8 inches in diameter, usually have a rough finished, unslipped exterior, and decoration confined to the interior only. Jars, exceedingly rare, seldom exceed 6 inches in height. Jars with either handles or lugs (fig. 2, *b, c*) as well as ladles (fig. 2, *e*) are also rare. Water was usually stored in larger jars of undecorated corrugated ware.

2. BISCUIT WARE[2] (circa A. D. 1350-1600), of soft greyish or light buff paste, with decoration in black on a slip usually of the same tone as the paste itself. Two successive types are recognized; Biscuit A and B. Biscuit A bowls (fig. 2, *d*), averaging 13 inches in diameter, have a rough unslipped exterior, with decoration confined to the smooth interior surface. Biscuit B bowls (fig. 2, *f*) ranging from 8 to 13 inches in diameter, are slipped both inside and out, and have both exterior and interior decorations. Biscuit ware jars (fig. 2, *g*) not so readily classified as A or B, varying from 9 to 12 inches in height, have decorations commonly used upon bowls.

[1] Amsden, in Kidder, 1931, pp. 17-72. Mera, 1935.
[2] Kidder, 1915, pp. 427-436; 1931, pp. 73-130. Jeançon, 1923.

4

3. GLAZED WARE,[1] (circa A. D. 1350-1680), contemporaneous with Biscuit wares, and more commonly used in the Keres area. Made of a greyish or light reddish paste, harder than that of the Biscuit wares. Several successive types are recognized, in which the slips vary from cream, or flesh tone, to red, on which the decoration is painted in a black or brown vitreous glaze. In some types red is also used to fill spaces outlined with glaze. Bowls (fig. 2, *h*), averaging 10 inches in diameter, have both exterior and interior decoration. Jars (fig. 2, *i*), averaging 10 inches in height, have designs somewhat similar to those of bowls.

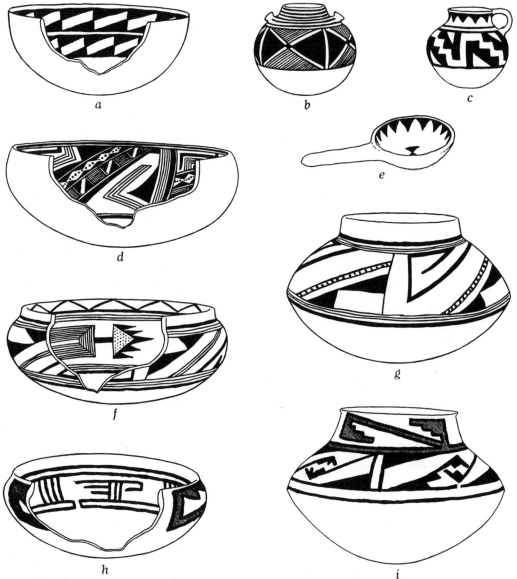

FIG. 2—Antecedent pottery types. *a, b, c, e,* Black-on-white ware; *d,* Biscuit A ware; *f, g.* Biscuit B ware; *h, i,* Glazed ware. Adapted from specimens, and from figures by Amsden, 1931, and Kidder, 1915, and 1931.

[1] Kidder, 1915, pp. 436-447.

POST-SPANISH POTTERY TYPES

Turning now to the early post-Spanish period, it might be assumed that the continuity of Pueblo life would have provided an unbroken sequence in ceramic types at conservative Santo Domingo. But unfortunately a gap of at least two centuries intervenes between the wares of the pre-Spanish period and those of modern times. The abundance of pre-Spanish Pueblo wares in museum collections is due to the ancient custom of interring pottery with the dead. However, with the coming of the Spaniards the use of mortuary pottery was discouraged, and the only specimens which have survived those early centuries of contact are the few which by good fortune were retired from use and stored in seldom used rooms. The wares of this period are the rarest of all Pueblo pottery. Although it is possible that such early examples may still be held at Santo Domingo, not a single specimen showing any evidence of a transition in form or decoration from pre-Spanish to present day types has yet appeared in the pueblo.

It is true that similarities can be found between the pre- and post-Spanish types in one or more of the details of paste, form, size, slip, pigments, and decoration. For instance, most modern bowls have the simple form of those of the ancient Black-on-white ware, and there is a marked similarity between some of the more simple geometric decorations of the two, as may be seen by comparing the following motifs of figure 3 with those in plates indicated in parentheses: *a* (43, *e*) ; *b* (43, *a*) ; *c* (43, *d*) ; *d* (16, *m*) ; *e* (13, *a, f*) ; *f* (19, *a*). Yet, as has been shown (p. 3) two

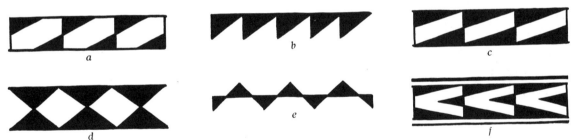

FIG. 3—Geometric designs from Black-on-white ware.

distinctive types of ware intervene chronologically between the two and neither of these has left any appreciable impress upon Santo Domingo bowl shapes or decoration. The creamy-buff slip of modern Black-on-cream ware may have been derived from a similar slip used in late phases of pre-Spanish glazed ware and a bowl form of the latter is occasionally used in modern times, but none of these similarities give convincing evidence of a direct derivation of modern Santo Domingo wares from any one of the three distinctive pre-Spanish types.

With the time range so definitely limited, it might be expected that the material to be studied could be arranged in a satisfactory chronological sequence. Yet, so meager is the information available as to the relative age of the known specimens, that it would be impossible to assign an age greater than 100 years to any of them.

Certain storage jars may be much older, but a comparison of such specimens of evident antiquity, with others of known recent make does not disclose any clear sequence in either form or design. Such large jars, however, form but a small part of the total of Santo Domingo pottery available for study during the past twenty years. The greater part of the decorative material used in this work has come from the more abundant supply of bowls and water jars, and these, as is noted under Forms and Uses (p. 9), are the least apt to have survived many years of constant use. It seems safe to conclude, therefore, that the designs to be considered are in greater part the product, though not necessarily the development of the past fifty years.

LITERATURE OF SANTO DOMINGO POTTERY

Santo Domingo pottery has received but scant mention and illustration in published accounts of the material culture of the Pueblo Indians. The earliest is that by Stevenson,[1] in 1883, in which one water jar is figured. This was followed in 1910 by Saunders,[2] who gives a photographic group of five specimens. Nothing further appears until the 1920's when further photographic reproductions are given by the Fred Harvey Company,[3] Kidder,[4] Alexander,[5] Chapman,[6] Goddard,[7] Sloan and LaFarge,[8] and Douglas.[9]

TERMINOLOGY

No attempt has been made to secure a Keresan terminology for the various ceramic materials, finishes, and decorations to be considered. While such Spanish terms as *olla* for cooking pot, and *tinaja* for water jar are well known and appear frequently in descriptions of Pueblo Indian pottery, these have been purposely avoided. Instead, generally accepted English terms have been chosen for use throughout.

TYPES

The wares produced during the past century or more at Santo Domingo are:

1. Culinary ware
2. Black-on-cream ware
3. Black-on-red ware
4. Black-and-red-on-cream ware[10]
5. Polished-red and Polished-black wares
6. Polished-red and Polished-black wares with matte decoration

[1] Stevenson, 1883, fig. 707.
[2] Saunders, 1910, p. LXIX.
[3] Fred Harvey Company, 1920, color plate.
[4] Kidder, 1924, pl. 18, c. In Guthe, 1925, pl. 3 g. (the specimen is not typical).
[5] Alexander, 1926, pl. XV, d, e.
[6] Chapman, 1927, p. 209; 1933, pls. 39-45.

[7] Goddard, 1931, fig. 22.
[8] Sloan and LaFarge, 1931, pl. XXXII.
[9] Douglas, 1933, figs. w, x, y; 1933-34, pls. 5, 6, 52-57.
[10] Since 1936, the more convenient term "Polychrome," has been adopted for this and similar wares of the Modern Pueblos.

CULINARY WARE

Pottery for use in cooking over an open fire has been produced in considerable quantities at Santo Domingo, as at other pueblos, since pre-Spanish times, though it has fallen into disuse in many homes, where iron kettles and other manufactured utensils are now largely in evidence.

In making culinary ware, the local clays must be tempered by mixing with coarse sand or gravel. In some instances a micaceous clay obtained in trade from other pueblos to the north is used without the addition of tempering material. Since cooking pots of this micaceous ware are often brought by the Tewa or Tigua people for sale or trade, it is difficult to determine what proportion of those now in use were made at the pueblo.

The exterior surface is left rough and undecorated, but the interior is carefully smoothed before firing by mopping or even by rubbing with a polishing stone. The ware turns light red in firing, though this is often purposely smudged to a more or less dense black after the firing is complete. In either case, the rough exterior surface soon becomes thickly coated with black from contact with the open fire. Even though thoroughly fired according to Pueblo standards, new cooking pots are more or less porous until subjected to use, when animal and vegetable fats permeate the clay and serve to prevent further seepage. Three typical forms are used: jars (fig. 4, *a*) 10 to 15 inches in height; bowls (*b*) 8 to 12 inches in diameter; and pitchers (*c*) 5 to 8 inches in height.

BLACK-ON-CREAM WARE

For centuries the typical decorated ware of Santo Domingo has been that with a creamy buff slip, with designs painted in black only. It is still made in considerable quantities for domestic use, but very little of it is now sold to tourists, who prefer the more recent types. Fully 75 per cent of the designs in the accompanying plates are taken from specimens of this ware.

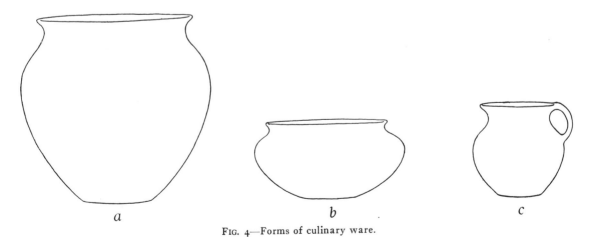

a *b* *c*

FIG. 4—Forms of culinary ware.

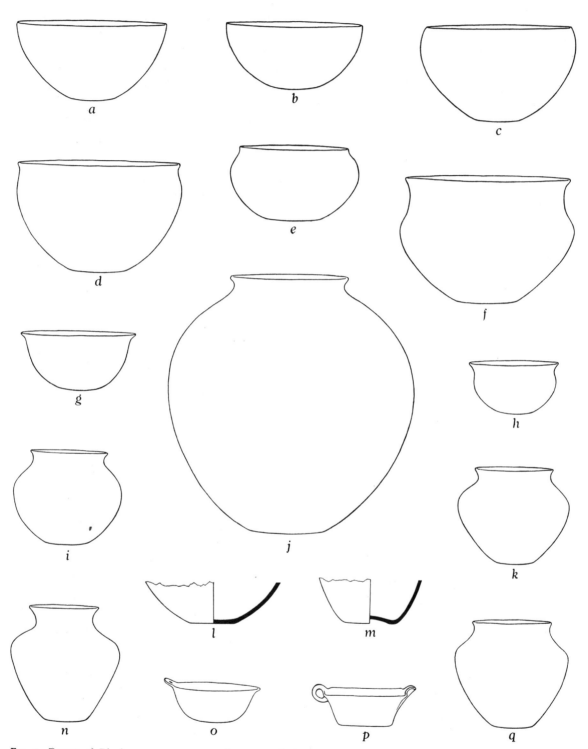

Fig. 5—Forms of Black-on-cream ware. *a, b, c, e, g, h,* food bowls; *d, f,* utility bowls; *i, n, k, q,* water jars; *j,* storage jar; *l,* cross section of base of bowl; *m,* cross section of base of water jar; *o, p,* sacred meal bowls.

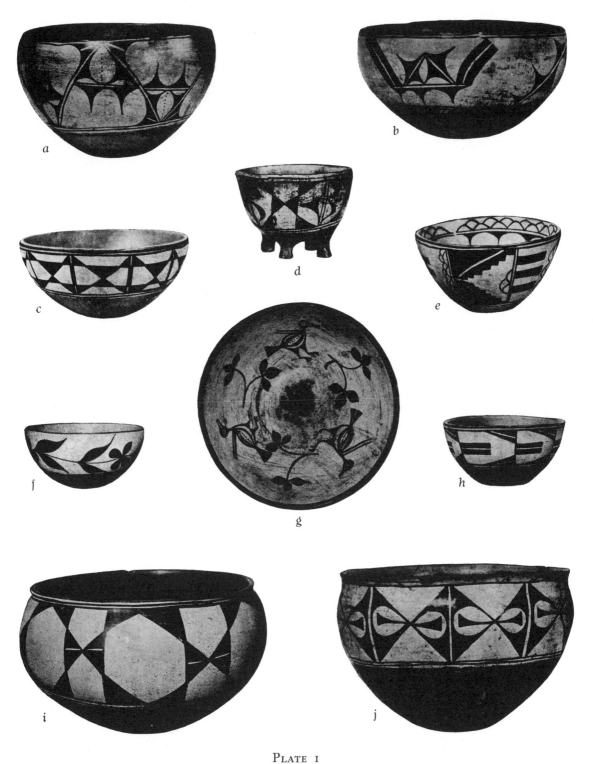

PLATE I

BLACK-ON-CREAM WARE BOWLS

a, b, c, f, g, h, food bowls; *d, e,* ceremonial bowls; *i, j,* utility bowls. Diameter of
i and j, 16½ inches; the others in approximate proportion.

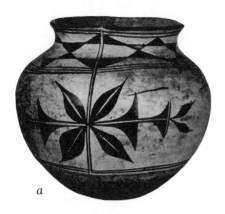

a

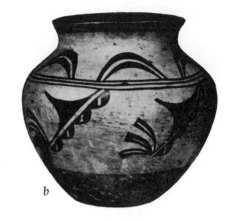

b

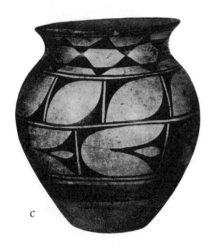

c

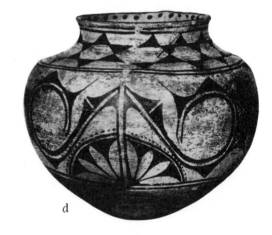

d

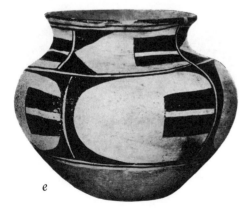

e

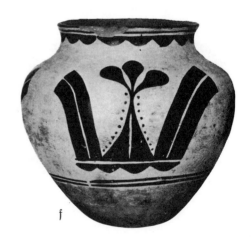

f

PLATE 2
BLACK-ON-CREAM WARE WATER JARS
Average height, 10 inches.

FORMS AND USES

FOOD BOWLS (pl. 1, *a-c, f-h*). These, between 8 and 12 inches in diameter, have a capacity varying from one quart to two gallons and are commonly used for serving both cooked and uncooked foods. Since tables are still rare in most homes, food bowls are usually placed upon the smooth earthen floor. Most of them have their greatest diameter at the rim (fig. 5, *a, b*), only a few specimens showing the contour of the larger utility bowls (fig. 5, *g, h*).

UTILITY BOWLS (pl. 1, *i, j*), between 12 and 18 inches in diameter, with a capacity of 2 to 4 gallons, are used only on special occasions for serving foods. They serve as receptacles for fruit, vegetables and grain, for mixing bread, whitewash, clay and other substances; for washing, and for various other purposes. While many of these have the simple contour of food bowls with the maximum diameter at the rim, others are modeled with a slightly constricted mouth, or with a pronounced outflaring rim (fig. 5, *f*).

WATER JARS (pl. 2; fig. 5, *i, k, n, q*). Jars, varying in height from 9 to 12 inches and with an average capacity of two gallons, are used for carrying and storing water for drinking and domestic use. A concave base permits the jar to rest directly upon the woman's head. Several may be in use in one home. These are sometimes filled by emptying into them the contents of one used particularly for carrying water. Their size is necessarily limited by the considerable weight of both jar and contents when carried upon the head. The average weight, filled to three-fourths' capacity, is nearly 20 pounds.

STORAGE JARS (pl. 3; fig. 5, *j*). These, varying from 13 to 24 inches in height, and with a capacity of five to twenty-seven gallons, are usually flat bottomed and more globular than the smaller water jars. They are rarely used for storage of water; instead, often permanently mounted upon earthen pedestals for protection against rodents, they serve for keeping dry foods, and particularly corn meal which accumulates as a surplus from the daily grinding. The meal thus stored is protected by a flat stone, board, or cloth laid over the mouth of the jar. In more recent years, with the increased use of wheat, such storage jars have also been made to serve as containers for the weekly baking of white bread.

SACRED MEAL BOWLS (figs. 5, *o, p;* 27, *a, c*). Bowls of this general type, rarely exceeding 9 inches in their greatest dimension, are found occasionally in use for serving food, though they are generally regarded as special forms designed to hold sacred meal consisting of finely ground corn, pollen, shell, and other ingredients, which is scattered to the six ceremonial directions by adults, when leaving the home on any important mission.

CEREMONIAL POTTERY. Pottery of special form and decoration is used in many pueblos during ceremonies conducted by groups and witnessed only by

initiates. Thus far only two specimens are known to have come from Santo
Domingo. One, a bowl, 7½ inches in diameter, is supported by four short legs
(pl. 1, *d*) ; the other is an unusually deep bowl, 11 inches in diameter (pl. 1, *e*).
The special significance of their decorations is discussed under Symbolism (p. 31).

OTHER FORMS. Canteens were once in general use in most pueblos for carry-
ing drinking water to the fields, or on other journeys. These were never plentiful
at Santo Domingo and no examples are available in the black-on-cream ware. Pot-
tery utensils of other forms are rarely seen in use at the pueblo.

Under ordinary circumstances the life of food and utility bowls and water
jars is comparatively brief. All these are in continual use upon the floor and out-
doors, and are daily subjected to wear and accidents. If slightly cracked, bowls
may be set aside for occasional service as receptacles for dry substances. The use-
fulness of water jars, when cracked, may be prolonged by a strip of rawhide
shrunken about the rim, or by a lacing of the same material about the entire body.
Occasionally cracks in jars are sealed with piñon pitch. Thus reinforced they
may hold water for some time but usually they serve only for the storage of dry
foods or other material and so may last for many years. Canteens are equally
subject to breakage. Storage jars, kept in secluded rooms, are less frequently
handled and particularly when mounted upon pedestals are comparatively safe
from breakage. Rarely, a cracked or broken jar may be laced with rawhide to fit
it for further service. Ceremonial pottery undoubtedly outlasts most domestic
ware since it is infrequently used and carefully stored between times in rooms
which serve no other purpose.

TECHNOLOGY

The fundamental processes in Santo Domingo pottery making are alike for
various types of ware. A different technique of finish is required, however, for
each type. Because of the preponderance of Black-on-cream ware, a somewhat
extended account of its production is given, while only the processes peculiar to the
finish of the later types will be considered in the description of those wares.[1]

MODELLING. The clay, light grayish red in color, is obtained in a dry state
from pits within a few miles of the pueblo, and is ground to a coarse meal before
use. Mixed with it is a tempering material of fine grey sand of volcanic origin,
which prevents the clay from cracking in drying, or later in the firing. The clay
and temper are moistened and kneaded together so that the mass is of an even tex-
ture and of the proper consistency for use. This accomplished, the potter is now
ready to begin her modelling. Seated upon the floor, she has before her a low box
or stand, upon which she places a shallow pottery dish which serves as a movable
base to support the new pot, a little sand serving to keep the wet clay from sticking
to its surface. First a flat cake of clay is patted into the dish to form the base of a

[1] A more intensive study of pottery making is that by Guthe, 1925, at the pueblo of San Ildefonso, where
comparable wares are made.

new pot (fig. 6, *a*). Successive rolls of clay are then pressed and bonded into place to form the walls (fig. 6, *b, c*). Next, with the use of a small oval spatula made from a piece of gourd rind, the skill of the potter shows itself as she extends the thick, straight sides into the shapely contour of a bowl by scraping from within,

 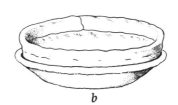 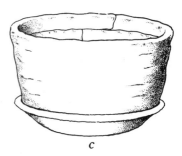

a b c

FIG. 6—Successive stages in modelling a pot.

meanwhile steadying the form by light pressure of the left hand upon the outside and giving the shallow dish an occasional quarter turn to insure the same modelling on all sides. To model a water jar, a base dish of special form is used, so that the base of the jar will be cupped, to permit of its fitting closely upon the head when carried (fig. 5, *m*). The construction proceeds as with the modelling of a bowl, but with the addition of further rolls of clay which are pressed on to the rim and scraped upward and inward to form the shoulders and neck. When the form is complete, the rim is deftly stroked into shape with the moistened tips of the fingers. This completed, the new bowl or jar, still too pliable to be lifted, is set aside in its base dish to dry. Often, a dozen or more pots of various forms and sizes are moulded in a day, and each in turn set aside for drying. The pots, now dry, or with the surface slightly dampened, are next scraped to reduce the thickness of the walls and to remove all irregularities of the surface, after which they are mopped with a pad of cotton cloth. This serves to fill any small pits left by the scraping, and to produce a smoother texture for the application of the slip. The finished thickness of bowls and water jars varies from one-fourth to three-eighths of an inch, while that of the largest storage jar measured exceeds nine-sixteenths of an inch.

SLIPPING AND POLISHING

Cream slip. A variety of light greyish bentonite, obtained from beds near the pueblo, provides an excellent slip. It is obtained in lumps which absorb water rapidly, so that it is readily prepared for use at the consistency of a thin fluid. This is mopped with a small folded pad of cotton cloth, over the exterior and interior surfaces of bowls, and over the exterior surface of jars, to cover the zone which is to be decorated. It must be applied repeatedly in thin coats, each of which must be dry before the next is applied. This is continued until the slipped surface becomes a smooth greyish white, completely covering the light reddish body clay.

While the surface is still slightly damp from the last application of slip, it is smoothed either by rubbing with a soft, dry cloth, or by polishing with a rubbing stone; a pebble of black quartz, jasper or other silicious stone which, with years of use, has acquired a highly polished surface. With this the damp surface is compressed and is given a much better gloss than that produced with the dry cloth.

Red slip. After the cream slip has been polished, a red slip is next applied to the underbody or lower portion of bowls and jars; to the interior surface of the necks of jars; and, in some cases, to either the entire exterior or interior surface of bowls. The red is an ocherous clay, obtained from the vicinity of the pueblo. Like the cream slip, it is applied with a pad of cotton cloth, one or two coats being sufficient to cover the surface evenly.

Buff slip. Buff is used in place of red on the underbodies of a small percentage of bowls and jars. An additional coat of red may be applied in a wide stripe to provide a more even edge between the red or buff underbody and the cream slip above.

PAINTING

The decoration of Black-on-cream pottery is produced by use of a pigment and brushes, both of which are supplied by native plants.

Pigment. The black is made from the juice of the Rocky Mountain bee plant, or *guaco (Peritoma serrulatum)*. The leaves and succulent stems of the plant are gathered in early summer and are boiled until the juice has been extracted. This, poured off as a brownish liquid, is then evaporated until it forms a dense black cake. It is later softened with water, as needed, to the consistency of a thin brownish syrup, so that it will flow readily from the brush.

Brushes. Painting is done with brushes easily prepared from the small blade-like leaves of yucca *(Yucca glauca),* or from larger leaves split into two or more strips varying from ¼ to ½ inch in width (fig. 7, *a*). An inch or more of one end is chewed until the loosened pulp can be scraped away, exposing the long, stiff, thread-like fibers which are to serve as bristles (fig. 7, *b*). If all the fibers are not needed, part are cut away at either side, leaving enough to make a brush of the desired width (fig. 7, *c*). The finished brush consists of an inch or more of the

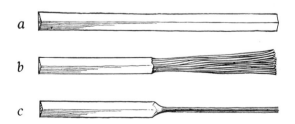
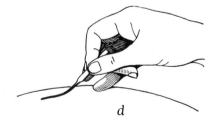

Fig. 7—Brushes and their use.

fibers projecting from the hand portion which is usually but two or three inches in length. It is used principally as a striping brush for painting lines approximately ⅛ inch in width. For this purpose it is held between the tips of the thumb and first finger of the right hand (fig. 7, *d*). The tip of the little finger rests upon, and glides over the surface of the pot as the hand is moved slowly and carefully toward the body, with each brush stroke, during which the fibers lie flat for over half their length. No better brush could be devised for drawing lines of uniform width, since with the "pulling" stroke the fibers lie closely parallel from base to tip. The narrow striping brush may also be used for painting spaces outlined as above, but others of greater width are usually made for this purpose, and for painting the wide rim-stripe on bowls and jars.

Brush technique. The technical quality of Pueblo pottery painting depends first of all upon the careful preparation and use of both pigments and brushes. The fluid must be free from dirt, dust and lint, so that it will flow freely from the brush without spreading in accidental blotches; and the brush must be well made and kept in good condition so that it will produce smooth lines of uniform width.

The average brush technique of the Santo Domingo potters, though showing a fluent use of good paint and brushes, is mediocre as compared with the best of other pueblos of ancient and modern times. The designs are applied with more freedom and skill than the average of those of near-by Cochiti, but they lack the precision of the carefully spaced and executed decorations of the other Keresan pueblos of Tsia and Acoma. The most glaring defects in Santo Domingo decoration are due, therefore, not to crudities of a faltering technique, but rather to haste and lack of forethought in planning and laying out the constructional lines upon which most of the decoration depends.

While as a rule the decorations of each piece are of the same technical quality as that of the ware itself, this does not always hold true, for there are examples of well made, shapely pots with exceedingly crude or careless decorations and of inferior pottery with well executed designs. This may be accounted for by the fact that ceramic decoration is a procedure entirely separate and distinct from that employed in pottery making itself. In this respect it differs from basket and textile decoration in which the designs are made by the very structural materials of the article itself, so that their technical excellence depends absolutely upon the care and skill exercised in the selection, preparation, and use of these materials.

With the completion of the decoration, the pottery is now ready for firing.

FIRING

Primitive methods still prevail in this final process of pottery making. No permanent kiln is used. Instead, the fuel is laid around and over the pots in a kiln-like structure which is usually entirely consumed in the firing. Wood was formerly used, but the introduction of cattle and sheep has provided a plentiful

supply of dung, a superior material which serves as both temporary kiln and as fuel. This, in the form of chips, or in flat slabs cut from old corrals, is carefully dried and kept under shelter. The firing is usually done at some distance from the houses. Larger bowls and storage jars are fired singly, while two or three water jars, or even a greater number of smaller pieces, may be included in one group. The ground, which must be dry, is first heated by building a wood fire upon it. Formerly the pots were then placed over the coals, upon small stones. In more recent times an improvised grate of iron pipe, rods, or wires is placed upon stones so that it rests a few inches above the coals. On this the pots are carefully stacked in an inverted position, and a brisk fire of kindling is started underneath. To avoid blackening their surfaces with smoke spots, the pots must be protected from contact with the fuel which is to be placed around and over them. In earlier times, fragments of old pots were used to cover them, but these have been replaced by flat pieces of old sheet iron or tin. Slabs of dung are then placed edgewise about the heap, forming a dome-like kiln. Smaller pieces are laid over the irregular spaces between slabs to hold the heat within. As the fire from the kindling increases, the inner surface of the dung kiln is ignited, and as this burns it throws an intense heat from all sides into the mass of pottery. Additional fuel may be thrust under the grate from time to time during the firing which continues until the slabs have been consumed by the flames. This is usually accomplished within one hour, during which the maximum temperature has reached approximately 700 degrees, Centigrade. As soon as the heat from the embers is endurable, the sheet iron is removed and set aside. The pots while still hot are then lifted from the grate by means of improvised pokers and placed upon the ground to cool. If the firing has been done with care, and under favorable conditions, the greyish white of the unfired slip will have turned to a rich creamy buff and the ocherous red clay to a somewhat deeper red; while the brownish *guaco* paint will have become a dense black. This, however, will be covered by a fine grey ash which must be removed by rubbing the surface with a greasy cloth. With such primitive means of firing, the results are often unsatisfactory. Wind may cause uneven firing, while dampness in the ground or fuel, and other unfavorable factors, may produce a smoky, greyish tone in both the cream slip and the black. If the firing has reached too high a temperature at one side or throughout the entire mass of pottery, the smooth cream slip will be roughened by crackling and blistering; the rich black pigment will turn to a light grey. If the firing has been insufficient the ware will be too soft for continued use. Fired at the average temperature, the Black-on-cream ware is somewhat more porous than the culinary pottery. In food bowls, the porosity is soon overcome by the deposit of fats from cooked foods which seal the pores. Some seepage is a desirable feature in water jars since it provides constant evaporation, which cools the contents; for this purpose they are still used in preference to manufactured utensils. Porosity does not affect in any way the usefulness of large pottery jars for storage. Through constant use, the

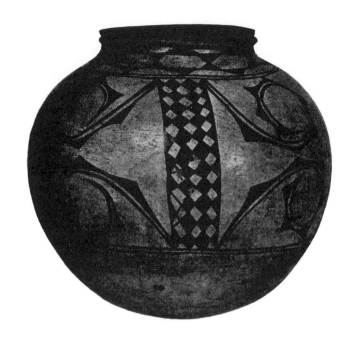

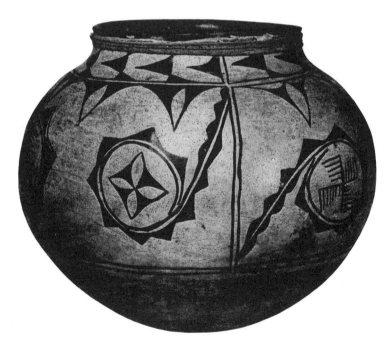

PLATE 3
BLACK-ON-CREAM WARE STORAGE JARS
Height of each, 17 inches.

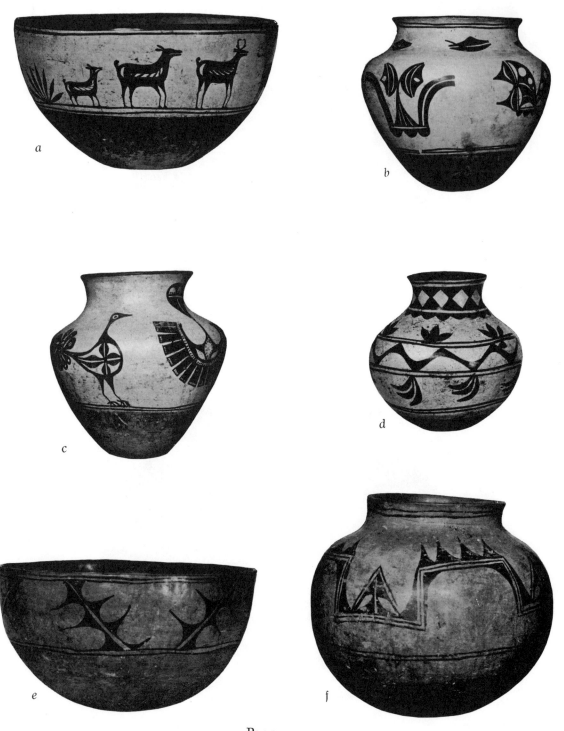

PLATE 4

BOWLS AND JARS OF BLACK-ON-CREAM WARE (*a-d*); AND BLACK-ON-RED WARE (*e, f*)

Diameter of bowls in inches, *a*, 16; *e*, 18. Heights of jars in inches, *b* and *c*, 11; *d*, 8; *f*, 16.

creamy buff slip of food and utility bowls and of water and storage jars becomes much darker in tone, often producing a more harmonious background for the dense black of the decoration.

DECORATION

While the personality of the potter may be expressed, to some degree, in the forms which she creates, their diversity is greatly limited both by the use for which they are designed, and by the community of thought which prompts each individual to adhere, within reasonable bounds, to forms which have been evolved through centuries of repetition.

In decoration, however, much greater freedom of individual taste is permitted, though here also the potter is limited, to a certain degree, both by decorative techniques which have been handed down from great antiquity, and by the desirability, and in many cases by the necessity of conforming with the conventions of a gradually evolving system of decoration sanctioned by long usage.

DISPOSITION OF DECORATION

Both freedom and limitation of choice are readily discernible in the decoration of Black-on-cream ware. The use of red is confined to certain areas. In covering the underbodies of both bowls and jars with red, or less commonly with buff, the Santo Domingo potters adhere to a decorative feature which distinguishes the post-Spanish pottery of most pueblos from that of pre-Spanish times. Either color may be reinforced at the top by a wide band of heavier red. The relative height of the underbody varies considerably. It usually covers the lower one-third of the height of the average bowl, and one-fourth the height of jars. Here the red or buff slip serves no useful purpose, but when it is applied to the inner surface of the necks of jars, or to the entire interior surface of some bowls, it provides a smooth, durable texture, easily cleaned, and well adapted to resist constant wear. Thus both decoration and utility are factors in the use of the red slip. In rare instances red is used for the entire exterior surface of bowls. In such specimens, decoration is confined to the cream slipped interior surface (pls. 7, 8).

While ancient custom also determines the portions which are to be decorated with black, much greater freedom is given the potter in determining the nature of the painted decoration. Here also another distinguishing feature of most post-Spanish Pueblo pottery is found, in the use of a black rim stripe. This feature is seldom omitted in Santo Domingo Black-on-cream ware, where it provides a convenient break between the exterior and interior surfaces of both bowls and jars. It is applied to the full width of the rim and may even spread down somewhat on either side. Its full width appears only when viewed from above. A narrow gap is usually left in the black stripe at one point. The purpose of this break is considered under Symbolism (*The Spirit Path*, p. 33).

LAYOUT

The major painted decoration appears upon the cream-slipped upper exterior portions of bowls and jars. Only rarely is it used on the interiors of bowls, or pendent from the rim on the interior surface of the necks of jars. The decorated zone of bowls and jars is invariably bordered at the top by one or, more commonly, by two parallel lines placed immediately below the black rim stripe; and at the bottom by another pair placed immediately above the red underbody. In the decoration of bowls, this space is usually treated as a single zone (pl. 1). Only rarely, in the instance of large, or unusually deep bowls is the space divided by another pair of horizontal lines, into two bands. In the decoration of jars, the cream slipped area is rarely treated as one zone. Instead, a pair of lines usually divides

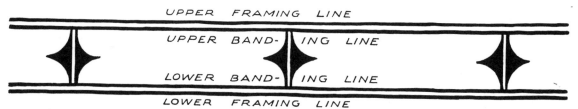

Fig. 8—Framing and banding lines.

the space into a shoulder and a body zone (pl. 2). Less frequently, additional paired lines are used to divide the space into three or more comparatively narrow bands (pls. 2, *c;* 4, *d*). For convenience the outer lines of a zone or band are termed framing lines, and the inner, banding lines (fig. 8). Where two bands adjoin, each of the intervening paired lines serves as a framing line for one band, and as a banding line for the other.

Within these single, double, or multiple zones or bands, other vertical, horizontal, or oblique lines, are used singly, or more frequently in pairs, as additional structural elements upon which the decorative details are to be placed. These might naturally be considered next in order, but since their use is best explained by an understanding of the nature of the decoration itself, the order has been reversed to permit of a preliminary study of the simplest details of decoration which recur throughout Santo Domingo design. These are shown in progressive order as they build up into devices which constitute the major decorative system of Santo Domingo.

CONSTRUCTIVE DEVICES, LINES, DOTS

The simplest constructional and decorative media used in Santo Domingo designs are lines, dots, and dashes.

Lines. By far the greater part of the decorative system is based upon the use of lines. Since these are painted with a brush so fashioned that it permits of but little gradation, all lines are drawn, at least intentionally, of uniform width.

Single Lines. Both straight and curved lines are used singly in outlining various spaces, most of which are to be filled with solid black. In this case the lines, as such disappear. However, unless they are obliterated by careless painting of the solid black, they still lend character to the contours of the black spaces, for seldom does the artist paint beyond the original outlines to improve the proportions or to correct minor irregularities.

Double Lines. Paired lines are used to enclose decorative zones, bands, and panels, and in the construction of various units of design. In rare instances a third line is added. The space between lines is usually somewhat greater than the width of the lines themselves.

Multiple Lines. Parallel lines in groups of more than three are never used as a border for zones, bands, or panels. They occur only as hatching, within outlined spaces in abstract designs (pl. 34, *c, i*) ; in leaves (pl. 48, *w*) ; and in the bodies of birds (pl. 59, *d*). Only rarely do they serve a more graphic purpose on the wings of birds (pl. 57, *a*).

Stripes. These are defined as lines made heavier by two or more overlapping brush strokes, or by filling the space between two parallel lines. Stripes are of rare occurrence in abstract designs (pl. 23, *a, b*). They appear more frequently as details in conventionalized plant and bird designs (pls. 54, 55, 60).

Cross Hatching. This medium is of minor importance in filling spaces. The lines may cross squarely (pl. 22, *a*) or obliquely (pl. 37, *d*).

Checker. A seldom used device. In this the structural lines usually parallel the outlines of the space which they fill (pl. 31, *k*). In only 2 examples are they placed diagonally (pls. 18, *m;* 33, *k*). In one they cross each other obliquely (pl. 38, *b*).

Dots. These are comparatively rare in Santo Domingo decoration. Since they are made by one application of the brush, their size is determined by its width and the amount of pressure applied. Dots are used in rows within outlined spaces (pl. 13, *n*) or closely bordering lines and spaces (pl. 13, *o*). In some instances they are lengthened into dashes (pls. 16, *k;* 61, *a*). Multiple dots, irregularly arranged, are occasionally used to fill outlined spaces (pls. 18, *d;* 25, *i*). Large dots or disks of black are rarely used. They are produced either by enlarging a dot with several curving strokes of the brush or by outlining first and filling in the resulting circle with black. Such large dots appear almost without exception in the eyes of birds (pls. 57-62). Their use in plate 53, *c* is unique.

ELEMENTS OF DESIGN

Santo Domingo decoration is built up largely of a few basic, irreducible elements of design which occur in various arrangements and combinations in the

greater part of all figures included in this work. While some of these elements might be considered as graphic, in that they resemble more or less remotely certain natural forms, they are all of very simple geometric construction. The names of three (cloud, leaf and feather) are those frequently used by several of the pottery-making pueblos. No satisfactory names could be had for the remaining four. Since they are referred to frequently in the description of designs, descriptive terms have been adopted for them; (cove, double cove, right angled triangle, and isosceles triangle). These, and the manner of their use, are considered in the order of their occurrence.

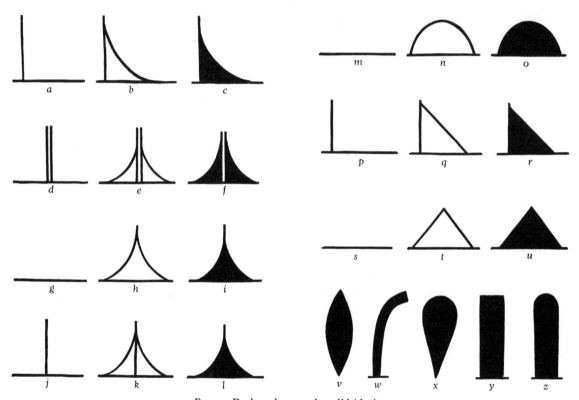

FIG. 9—Design elements in solid black.

1. Forms painted in solid black. In every instance these are first outlined and then filled with solid black, as shown in three stages of each of seven elements (fig. 9).

 The Cove (fig. 9, *a-c*), made by drawing a curved line across a corner produced by two lines meeting at a right, obtuse, or acute angle. It is frequently used in opposed pairs (fig. 9, *d-f*).

 The Double Cove (fig. 9, *g-i,* and *j-l*), made either by bringing two curved lines from a straight line to one point (fig. 9, *h*), or by placing two coves in adjacent right angles (fig. 9, *k*).

The Cloud (fig. 9, *m-o*), made by attaching an approximate half circle to a straight line. Examples appear in plates 7, 8, 10, 54 and 56.

The Right-Angled Triangle (fig. 9, *p-r*), and the *Isosceles Triangle* (fig. 9, *s-u*). These are nearly always produced by the crossing of straight lines in the construction of commonly used geometric designs (pls. 16, 17). As entities, used singly or in rows, however, they are exceedingly rare (pl. 10, *a, b*).

The Leaf (fig. 9, *v-x*), is considered as an element only when used in the embellishment of abstract designs disassociated from plant forms. The lanceolate form (*v*) is the most commonly used. The stripe (*w*) appears mostly in pairs, combined with other elements in formalized designs (pls. 54-56). From information gained in other pueblos, the obovate form (*x*) may be interpreted as either leaf or feather.

The Feather (fig. 9, *y, z*), is seldom used as a detail of abstract designs.

2. Outlined forms. These are used only rarely. The group includes mainly the outlined forms of the solid black elements given in figure 9. With the exception of leaf forms, they are seldom left without a filling of dots, lines, cross hatch, or checker (fig. 10).

3. Open space forms. In addition to the elements in solid black or outline, a few simple open devices are used to break up solid black spaces. These are out-

FIG. 10—Devices in outlined spaces.

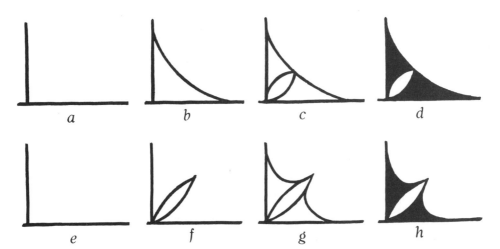

FIG. 11—Development of open space elements within the cove.

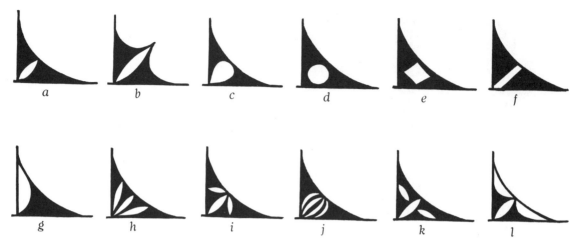

FIG. 12—Open space elements used within the cove.

lined before the solid black is applied, as shown in the four successive stages of two distinct uses of the open lanceolate leaf form, in figure 11. In one (*a-d*) it is drawn after the cove has been outlined. In the other (*e-h*) the relatively larger lanceolate space is outlined first (*f*) after which a curved line is used to enclose the space on either side (*g*). The lanceolate form is most commonly used within the five simple black elements shown in figures 12 to 16, inclusive. Other devices, more rarely used, follow in the order of their occurrence, in each element. These open space devices usually appear singly (fig. 12, *a-g*). Combinations of three or more

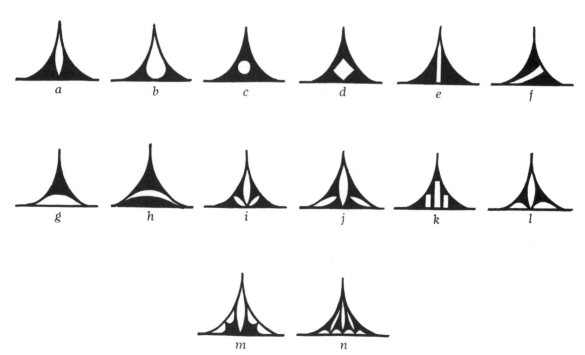

FIG. 13—Open space elements used within the double cove.

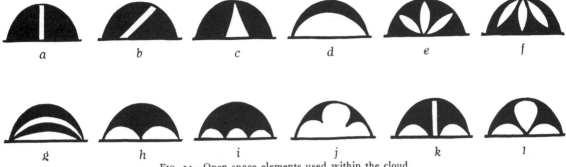

FIG. 14—Open space elements used within the cloud.

are sometimes used (fig. 12, *h-k*), and, more rarely, two distinct forms are found in combination (fig. 12, *l*). Examples of these various types appear also in figures 13 to 16, inclusive.

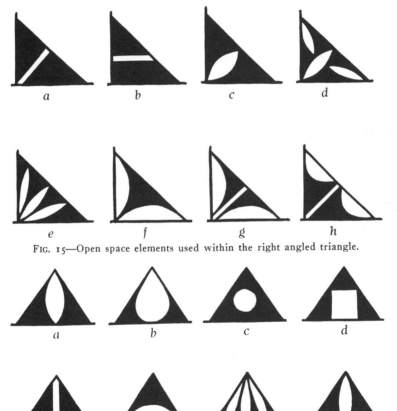

FIG. 15—Open space elements used within the right angled triangle.

FIG. 16—Open space elements used within the isosceles triangle.

MOTIFS

The foregoing commonly used elements of design (figs. 9-16) are employed in building up the great variety of more complex devices which are here classed under the general head of motifs.

Naturally some difficulty is encountered in determining a classification that will serve to distinguish between elements and motifs, for, in certain instances the elements (cloud, etc.), are definitely named entities which are used of themselves, without accessories, in repeated arrangements as border designs. But in greater part the decorations of Santo Domingo pottery consist of various motifs, each of which is composed of two or more elements.

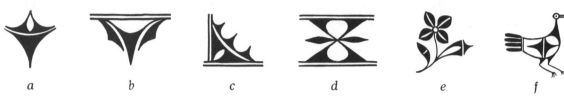

FIG. 17—Abstract and graphic motifs. *a-d*, abstract; *e, f*, graphic.

The motifs may be classed as abstract (fig. 17, *a-d*) and graphic (*e, f*). The greater part fall into the former classification. They include detached forms (*a*), and a far greater number which are attached to lines (*b*) or developed in corners (*c*) or between the borders of bands (*d*). The graphic motifs (*e, f*) form a smaller but important group.

ARRANGEMENTS

Santo Domingo pottery decoration owes its great variety largely to the varied arrangements in which both irreducible elements (figs. 9-16) and more complex motifs (fig. 17) are used. The more common of these arrangements are:

1. Detached Units. The limited range of variation in arrangements of detached units is shown in figure 18, in which a simple element is used. The arrangements are as follows:

(a) Repetition of units.
(b) Alternate inversion of units.
(c) Repetition of elements placed obliquely.
(d) Alternate reversal of elements in oblique position.
(e) Elements in pairs, with points usually averted.
(f) Group of four elements, with points usually averted.

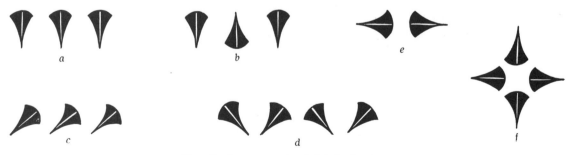

FIG. 18—Arrangements of detached units.

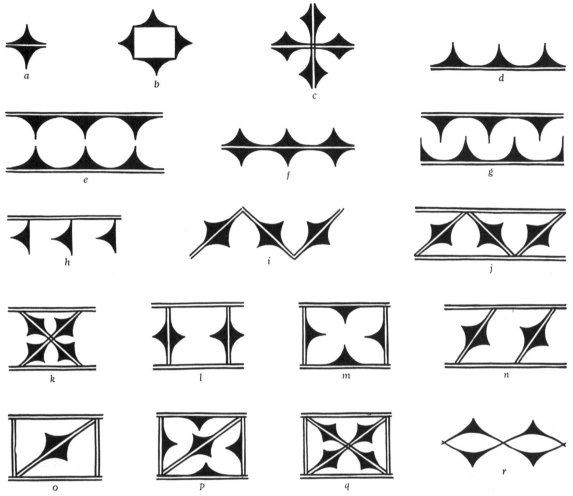

FIG. 19—Arrangements of units attached to lines.

2. *Units Attached to Lines.* A greater variety of arrangements is found in the use of units attached to lines (fig. 19). In this the double cove has been used throughout the series. The arrangements include:

(a) In pairs.
(b) Upon four sides of a rectangle.
(c) Upon crossed pairs of lines.
(d) Repetition of units attached to a framing or banding line.
(e) Repetition of units in two opposed rows on banding lines.
(f) Repetition of units on opposite sides of paired lines.
(g) Repetition of alternately placed units in two opposed rows on banding lines.
(h) Upon vertical lines attached to horizontals.
(i) Upon paired zigzag lines.
(j) Upon paired oblique lines placed in zigzag arrangement in bands.

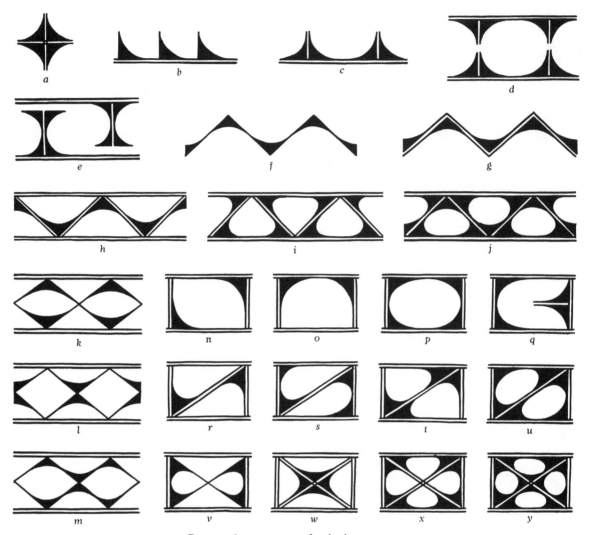

FIG. 20—Arrangements of units in corners.

(k) Upon crossed paired oblique lines within bands.
(l) Upon paired paneling lines.
(m) Upon both banding and paneling lines.
(n) Upon oblique paired lines within bands.
(o) Upon paired diagonal lines within panels.
(p) Upon banding and paneling lines, and paired diagonal lines within panels.
(q) Upon paired diagonal lines crossed within panels.
(r) Upon curved lines of repeated leaf space forms.

In *a, b,* and *h* the double cove motif extends the full length of the straight lines on which it is placed. In these, however, as in all the others the lines were drawn first and the motif was developed upon them.

3. Units in corners produced by lines meeting at right, acute, or obtuse angles.
In this much larger group (fig. 20), the simple cove has been used to illustrate the
various arrangements as follows:

(a) Upon crossed paired lines of detached units.
(b) Repeated upon framing or banding lines.
(c) Opposed pairs on framing or banding lines.
(d) Opposed pairs on opposite sides of bands.
(e) Alternating pairs on opposite sides of bands.
(f) In angles of single zigzag lines.
(g) In angles of paired zigzag lines.
(h) In one angle of each triangular space formed by paired oblique lines in
 zigzag arrangement within bands.
(i) In two angles of each triangular space formed by paired oblique lines in
 zigzag arrangement within bands.
(j) In three angles of each triangular space formed by paired oblique lines
 in zigzag arrangement within bands.
(k) In upper and lower corners of diamond spaces formed by crossing of two
 opposed zigzags within bands.
(l) In contiguous angles of triangular spaces formed by crossing of two op-
 posed zigzags within bands.
(m) In the angles of both diamond and triangular spaces formed as above.
(n) In diagonally opposite corners of panels.
(o) In horizontally opposite corners of panels.
(p) In all four corners of panels.
(q) In upper and lower corners of one side, and in corners formed by paired
 horizontal lines at middle of opposite side of panels.
(r) In one angle of each of two triangular spaces produced by paired diagonal
 lines within panels.
(s) In two angles of each of two triangular spaces produced by paired
 diagonal lines within panels.
(t) Same as *s.*
(u) In three angles of each of two triangular spaces produced by paired
 diagonal lines within panels.
(v) In two angles of horizontally opposed triangular spaces formed by cross-
 ing of single diagonals within panels.
(w) In one angle of each of four triangular spaces formed by crossed paired
 diagonals within panels.
(x) In two angles of each of four triangular spaces formed by crossed paired
 diagonals within panels.
(y) In three angles of each of four triangular spaces formed by crossed paired
 diagonals within panels.

Not all the possibilities of this device are used by the Santo Domingo artists. For example the single cove could be placed in any one of three angles of a triangular space; yet it is used commonly in only two positions (*h,* within isosceles; and *r* within right-angled triangles). Likewise three arrangements of two coves are possible within the same triangular spaces; yet only two are used within isosceles (*i, v,* and a combination of the two in *x*) and two within right-angled triangles (*s, t*). A similar variety of positions is also offered in placing two coves in the angles of rectangular spaces, but of all the possibilities only two have been used (*n, o*), though these are found occasionally in an inverted position.

Such arrangements of one or two coves within triangles and rectangles are generally used in extended bands similar to that on the shoulder of the jar in plate 2, *c,* and experiments have shown that those in the several figures from *h* to *x,* inclusive, are the most effective for that purpose. It is likely that the other positions have been tried and discarded.

 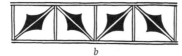

a b c d

FIG. 21—Static and dynamic arrangements.

Static and Dynamic Arrangements. It will be noticed in the foregoing that two basically different types of arrangements are commonly used in Santo Domingo decoration; static or balanced (fig. 21, *a*), and dynamic or unbalanced (*d*). Designs of the dynamic type predominate in the decoration of other pueblos, but at Santo Domingo static arrangements appear in more than 55 per cent of the bands of bowls, and in 75 per cent of the single, double, or triple bands of jars. Under this broad classification static arrangements also include many designs, the units of which are dynamic, but which are so alternated that they form zigzag arrangements in which there is no dominant movement either to right or left (*b*). The best of these typical static designs of the Santo Domingo artists adapt themselves structurally to the simple forms of bowls and jars, producing an unusually pleasing harmony of form and decoration.

The dynamic arrangements include both those which give the effect of motion horizontally (*c*), and others which give a repeated oblique lift to the design (*d*). Of these, the arrangement extending as in *d* from upper right to lower left appears in fully 90 per cent of all designs of this type. This is due, apparently, not to preference but to the position in which the bowl or jar is held by the rim in the left hand, which makes it more convenient for the right handed artist to draw oblique lines in this direction (fig. 22).

Secondary Background Spaces. In some instances the cove, the double cove, and other elements and motifs are so placed within extended bands or panels that they wholly or partly surround background spaces which are thus brought into

prominence. These are particularly noticeable in several figures of plates 11, 14, 26, 27, 28, 30, and 31, where, in such flat extended drawings, they are far more apparent than when viewed upon the pots themselves. One has only to copy such designs, however, to realize that the potter is concerned primarily with the development and grouping of the forms which she is painting in black, and that the resulting background spaces, however pleasing they may be, are largely fortuitous.

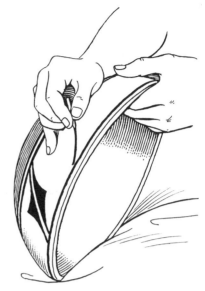

FIG. 22—Position of the hand in painting oblique lines.

Perhaps the potter foresees that the space enclosed by four coves within a panel will be round or oval (pl. 27, *m, o*) and that the use of four double cove units within a panel will produce a four petalled flower form in the open space (pl. 28, *k, l*), but it is doubtful whether such open space forms as those in plate 26, *h* to *k,* inclusive, were anticipated.

Repetition and alternation of panel arrangements and motifs. In the normal panelled band there is a regular repetition of identical arrangements in each panel (fig. 23, *a-c, e*). These may be either static (*a, b*) or dynamic (*c, e*). Occasionally variety is produced by shifting the position of motifs in alternate panels (*d, f*). More rarely an alternation of contrasting motifs is used in successive panels (*g, h*).

In *a* there is a symmetrical arrangement of motifs both vertically and horizontally, which cannot be varied. In *b* variety could be produced by inverting the

FIG. 23—Repetition and alternation of arrangements within panels.

motifs of alternate panels, but such a device is never used. In *c* there is a regular repetition of the motifs in each panel; in *d,* by reversing them horizontally, in alternate panels, a zigzag arrangement of the open leaf shaped spaces is produced. In *e* the arrangement of motifs is alike in successive panels; in *f* the arrangement is reversed in alternate panels to produce an alternation of pairs of unlike motifs developed upon the panelling lines. In *g* contrasting motifs are used in alternate panels of equal length. In *h* greater contrast is produced by placing contrasting motifs in panels of unequal length.

FIG. 24—Bordered bands.

Bordered bands. In rare instances particularly in the interiors of bowls, cloud and other simple motifs are used as exterior borders of decorated bands (fig. 24). If these are small, their usual haphazard spacing in relation to the larger arrangements within the band is not noticeable (*a*). If they are comparatively large, their informal relation to the band motif is apt to be disturbing (*b*). Even more rare are instances of the use of such borders both above and below bands (*c*).

Relation of two or more bands. In distributing the decoration within two or more bands, the artist is influenced more by the form of the bowl or jar than by any other factor. Since the division between neck and body of water jars comes well above the middle, the neck band is invariably narrower than that of the body. Where two or more bands are used upon either the neck or body of a jar, or upon both, there is usually a considerable variance in their widths (fig. 25).

With full freedom of choice of either static or dynamic arrangements, or of combinations of the two in two adjoining bands, a decided preference is shown for static designs. These appear in both upper and lower bands of 57 per cent of all specimens examined. Combinations of static and dynamic appear in 36 per cent, while dynamic designs alone are used in both upper and lower bands of only 7 per cent. In jars with three or more bands, static designs appear in only 38 per cent; combinations of static and dynamic in 60 per cent, thus leaving only 2 per cent of jars with three or more bands in which only dynamic designs are used.

In the pottery decoration of most modern pueblos, there is a characteristic disregard for regularity in the vertical alignment of motifs within two or more adjoining bands. In the decorative systems of some pueblos, such as Zuñi, the regularly used motifs of neck and body bands of jars are usually so complex and so unlike in size and form that this hit or miss relation between the two is not at all disturbing.

Such irregularity is most noticeable, however, in Santo Domingo design, and particularly where bold, simple geometric motifs are used in two adjacent bands (fig. 25). This lack of correlation in spacing is least apparent in such combinations

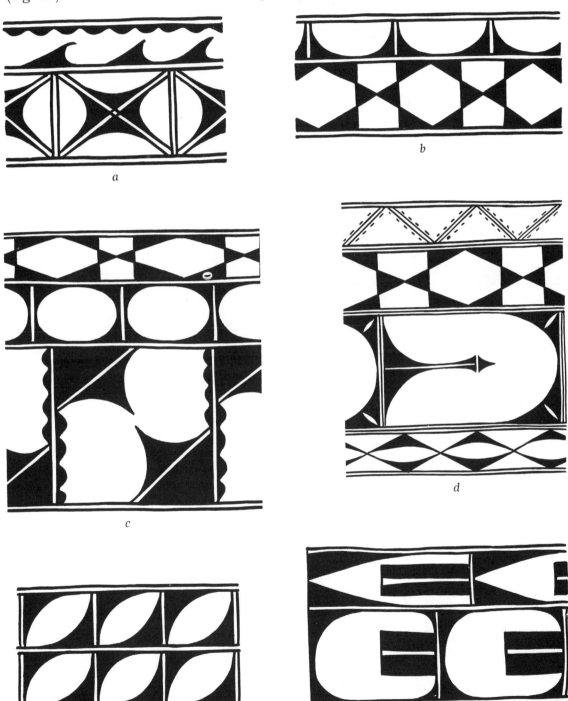

Fig. 25—Relation of arrangements in two or more bands.

as that in *a,* in which small and obliquely placed motifs of the neck band are used over a larger, static panelled motif of the body band. Such informal arrangements become more noticeable in *b,* because of the use of verticals in both bands. In *c* and *d* three and four bands are used. In transferring these designs to a flat surface it has been necessary to extend the neck and shoulder bands but the relative alignments of the motifs have been preserved. In *c* the lack of alignment between the vertical lines of all three bands is most disturbing. In *d* verticals are used in only two bands, but the variety of motifs is equally confusing.

The lack of vertical alignment becomes particularly noticeable in the rare specimens in which similar or identical motifs are used in adjoining bands (*f*). Only two specimens have been found which show a well planned regular alignment of verticals in two adjoining bands. In one of these (*e*) the unusual regularity of layout may have been prompted by the selection of identical motifs for both bands, a treatment unique in Santo Domingo decoration.

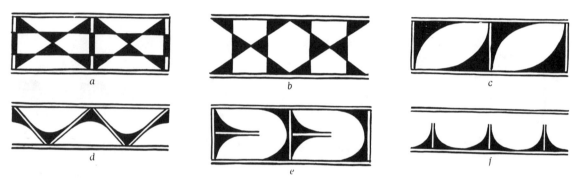

FIG. 26—Dominant motifs.

Dominance of Certain Motifs. In casual observations of Santo Domingo decoration for many years before this study was begun, a few motifs were observed in such abundance as to give the impression that these in their simplest form constituted nearly the entire range of designs then in use. Since no satisfactory census could be made of specimens at the pueblo at any one time, it is now impossible to determine whether or not there has been an increase in variety of design in the Black-on-cream ware of the past thirty years, but it is apparent that the few motifs then so much in evidence still predominate in the decoration of this ware. While their relative proportion in present day production cannot be estimated with any degree of accuracy, it seems safe to say that well over 50 per cent of all the decoration of Black-on-cream ware consists of the six motifs shown in figure 26.

These therefore, through thousands of repetitions, outweigh in importance the more than nine hundred other designs in plates 7 to 62, inclusive, many of which may never have been repeated. They reflect the preference of the Santo Domingo potters for comparatively simple designs, predominantly static in type, which have been in constant use for a century or more.

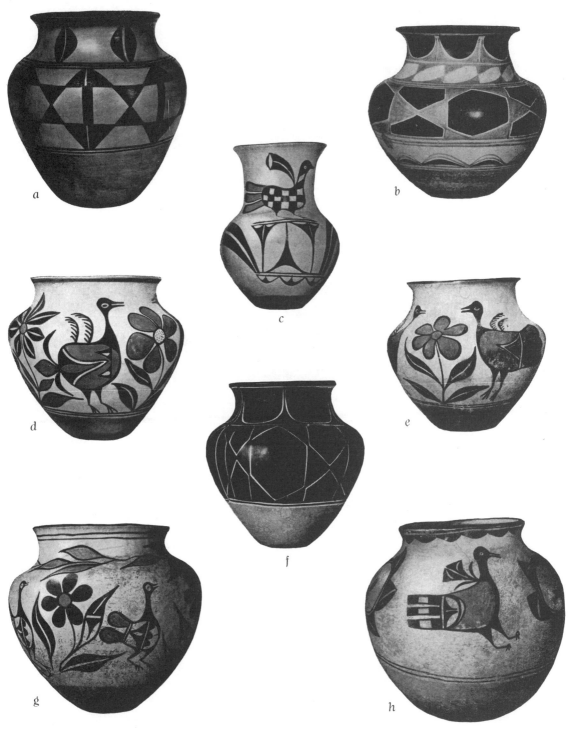

PLATE 5
WATER JARS OF SEVERAL TYPES

a, Black-on-red ware; *b, c, d, e, g, h*, Black-and-red-on-cream ware; *f*, Black-on-
cream ware, with secondary spaces filled with black. Height of *g* and *h*, 12 inches;
the others in approximate proportion.

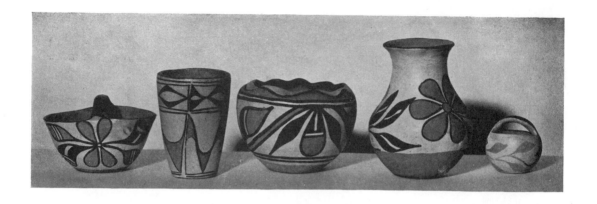

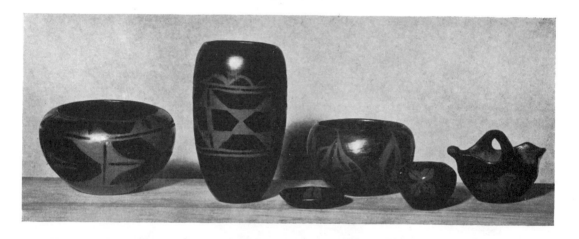

PLATE 6
POTTERY MADE FOR THE TOURIST

Above, Black-and-red-on-cream ware; *middle*, Polished-black ware with matte black decoration; *below*, typical designs used for matte black decoration.

Decorative system of bowls and jars. In the pottery decoration of Tsia, Zuñi,[1] and certain of the Hopi pueblos, the motifs and arrangements on the exteriors of bowls are quite unlike those developed for particular use upon jars. This adherence to distinctive uses of designs is carried still further at Zuñi[2] where certain motifs are invariably reserved for the necks of jars, while others are confined to the body zone. At Santo Domingo, however, there appears to be no such well defined rule, and adaptability seems to be the controlling factor in their selection for use in narrow or wide spaces. Thus many simple geometric motifs are used in bands interchangeably, both upon bowls and upon the necks and bodies of jars. Certain, large, detached units such as bird, plant, and abstract motifs are placed usually upon jars without a limiting band between neck and body. The freedom of comparatively large spaces has apparently prompted their use here, rather than within the more restricted decorated zones of bowls. The inner surface of bowls presents itself as an inviting unit of space, susceptible of decorative arrangements quite distinct from the usual band designs upon the exterior surface of both bowls and jars, and good use of this space is made by the potters of some of the other pueblos. But the interior decoration of bowls is exceedingly rare at Santo Domingo and the few examples show no unity of conviction as to the proper use of the space (pls. 7, 8). Apparently this is due in part to the prevailing preference for an interior finish of polished red upon which painted decoration is unsatisfactory, since the *guaco* pigment does not burn to a good dense black on the red clay.

SYMBOLISM

Similar studies of the decorative art of other pueblos have shown that but little importance is now attached to the meaning of most commonly used motifs. Since it has been impossible to investigate such matters at Santo Domingo, but little information has been obtained on the subject of symbolism, and the observations under this head are limited mainly to those motifs and devices which are also commonly used in other pueblos where such matters are more freely discussed. The subject is therefore considered mainly in its relation to the use or avoidance of a few well known motifs, the manner and frequency of their use, and the effects of symbolic devices upon the general character of Santo Domingo decoration. The black semi-circular elements commonly used in an extended border (pl. 10, *c*) are generally interpreted as dark clouds, heavy with rain, and these same elements, used less frequently in panels and other arrangements (pls. 11, *o*; 54, *a, b, e-g*) may also bear the same meaning. Groups of lines denoting rain falling nearby are much less in evidence (pls. 20, *l*; 41, *e*). Much heavier stripes (pl. 21) may also have the same significance, though they resemble the feathers of conventionalized birds (pl. 60). Where the double cove element is used with its point down-

[1] Zuñi, in extreme western New Mexico, and the Hopi pueblos of northeastern Arizona, lie outside the area included in the map, figure 1.

[2] Bunzel, 1929, pp. 13, 15.

ward (pl. 11, *a*) it may also have a meaning similar to that given at Cochiti and other pueblos, of the black cloud pouring rain far off.

The combination in one symbolic device of clouds, rain and lightning, frequently used in other pueblos, and with particular freedom at nearby Cochiti, is not found in the decoration of Santo Domingo; indeed there is evidence of its absolute prohibition upon pottery made either for domestic use or for sale. A combination of clouds and rain appears upon two specimens in the collection of the Indian Arts Fund, but both were evidently made for use in ceremonies which in themselves are elaborate prayers for rain. In one (pl. 1, *e*) the device is repeated four times in the exterior band of a bowl. It consists of lightly outlined forms of semicircular clouds combined with unusually heavy rain stripes. Although the device

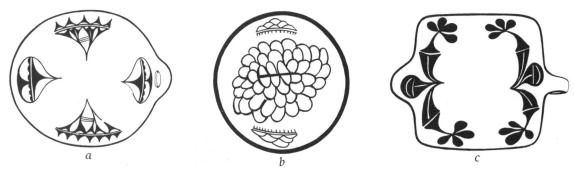

FIG. 27—Interior decoration of ceremonial (*b*) and sacred meal bowls (*a, c*).

as used by other pueblos would usually be placed upright, in this case it does not lose its symbolic import when placed sidewise within a band. The interior decoration consists of a band of clouds above double cove symbols of distant rain. In the other (pl. 1, *d*) the exterior decoration of the four legged bowl consists of a commonly used abstract design with an added device which combines the symbols of clouds and distant rain, grouped on paired vertical lines. Rain symbolism also appears in the interior where two crudely outlined cloud banks combined with rain lines are placed on either side of a larger bank of clouds (fig. 27, *b*). Even in these bowls, undoubtedly made for ceremonial purpose only, there is an avoidance of the potent zigzag lightning symbol so freely permitted on pottery for domestic use or for sale at nearby Cochiti. There is a possibility that lightning was intended in one design from a storage jar (pl. 42, *g*) in which the zigzag line connects two devices which may be interpreted as clouds with appendages of the double cove or "rain far off" symbol.

Number of Repeats. The use of six repetitions of motifs in the circuit of jars or bowls was once apparently a matter of considerable significance among the pueblos in that it symbolizes the six cardinal directions, namely, north, south, east, west, above and below. No importance seems ever to have been attached to this concept at Santo Domingo, for the range in number of repeats is as great in antique

specimens as in those produced today, the number varying from two, to thirty-one. Of a total of 125 specimens examined, those with arrangements of 2, 4, 5, 7, and 8 repeats are each used more frequently than those with 6, the latter constituting but 11 per cent of the total.

The Spirit Path. The gap in encircling lines of jars and bowls, commonly known as the "exit trail of life," ceremonial path," or "spirit path" is the most conspicuous and constantly used symbolic device in Santo Domingo decoration.[1] Originating in pre-Columbian times, it is found in occasional specimens of the ancient Black-on-white ware, and more commonly in the succeeding Glazed wares, but not in the contemporaneous Biscuit wares, A and B. It survives chiefly at Santo Domingo, Cochiti, Zuñi, and Hano,[2] where the ancient belief still persists that every pot is the abiding place of a spirit which is manifested by the resonance of the vessel when tapped, and that to curb its freedom of exit and return by painting completely encircling lines is to endanger the vessel which may be broken through the efforts of the spirit to pass these barriers. The line break occurs in

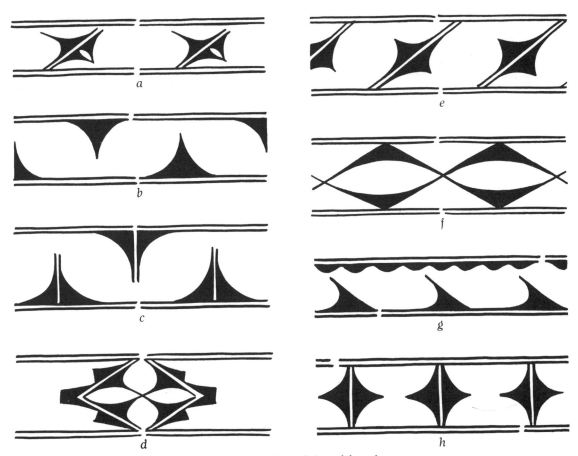

FIG. 28—Variations of the spirit path.

[1] Chapman and Ellis, 1951.
[2] A Tewa pueblo in the Hopi group of northern Arizona.

more than 90 per cent of all Santo Domingo pottery.[1] It is clear that this is the first consideration in planning and laying out the decoration for it is left in the encircling framing and banding lines which are the first to be drawn.

Two types of break are used in both antique and modern specimens. In the first (fig. 28, *a-h*) the gaps in the upper and lower framing and banding lines are comparatively inconspicuous; in the second (fig. 29, *a-d*) they serve as the upper and lower entrances to a narrow path bordered by a pair of vertical lines. In the

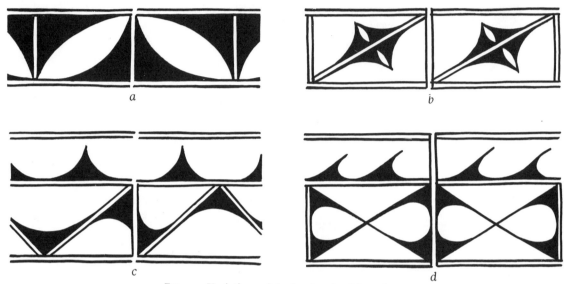

FIG. 29—Variations of the bordered spirit path.

first type the decoration is usually planned so that an unobstructed space is left between the upper and lower breaks (fig. 28, *a-c*). In *a* the decorative motifs are placed at some distance from the breaks. In *b* they adjoin the breaks but do not interfere with the free space between them. In *c* the upper motif has been placed so that it straddles the break. That the device fulfills its symbolic purpose, even though communication between upper and lower breaks is blocked by the decoration itself, is indicated by numerous instances, examples of which appear in *d, e,* and *f*.

In *d* the diamond motif has been carefully drawn so that it provides an open space between the breaks, but this has then been closed by the addition of decoration within the diamond. In *e* communication has been closed by the paired lines of the criss cross zigzags which effectively block the space between the breaks. In a few instances the upper and lower breaks are not vertically aligned (*g, h*). These may even be separated by a distance of a quarter or more of the circuit of the pot. With this, however, the path between the two breaks may not be obstructed, particularly if the decoration does not extend entirely across the band space (*g*). But

[1] Only a few specimens in plates 1 to 6, incl., have been posed to show the gap. It appears in the following: 1, *b, e*; 2, *a, d, e, f*; 3, *below*; 4, *b*; 5, *f*.

it is impossible to avoid blocking the space if the motifs are attached both above and below (*h*).

The second type, the bordered path, is far more commonly used (fig. 29, *a-d*). In *a* the paired verticals connect only the inner or banding lines. In *b* they connect both banding and framing lines. In *c* they are used only in the lower or body band of a jar. In *d* they extend from rim to underbody, through both neck and body bands. Several specimens have been noted in which the framing and banding lines are so carelessly painted that they close the passage through the spirit path. Such mistakes are never corrected.

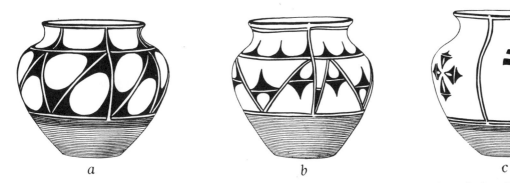

FIG. 30—Jars showing the bordered spirit path; *a*, continuity of design unimpaired; *b*, continuity of both neck and body design interrupted; *c*, most conspicuous use of the bordered path.

In some specimens the bordered path is so incorporated in the design that it is scarcely noticeable at a casual glance (fig. 30, *a*). In many others, a break in the continuity and even spacing of the design appears at the path (figs. 30, *b*; 31, *b*). This is due to the fact that the painting of the decoration is seldom planned and finished as a unit on both sides of the path, as in figure 29, *a*. Instead, as painted by right handed artists, the decoration begins at the left of the path and proceeds from right to left or from far to near, as the pot is held by its rim in the left hand, with its base resting upon the right knee (fig. 22). Thus as the decoration proceeds about the pot the space to the right of the path is the last to be decorated. The usual variance between this and the initial decorative unit at the left is due almost entirely to lack of preliminary planning in the spacing of repeated units of the design. Several means of adjusting this variance in spacing at the right are shown in figure 31. In *b* the zigzag arrangement of paired lines has been brought upward with an abrupt slant in the narrow space remaining at the right of the break in an attempt to preserve continuity. In *c* the arrangement terminates at the right of the path with its last lines slanting downward, thus leaving a break in its rhythm. With careful spacing of panelled bands, the final panel at the right may not be noticeably longer or shorter than the others (*d*), but usually the potter finds it necessary either to extend the motif in the final panel (*e*) or, more often, to divide the long space so that the final panel is much shorter than the others (*f*). Various means are used for filling such shorter panels. Among these are a condensed ver-

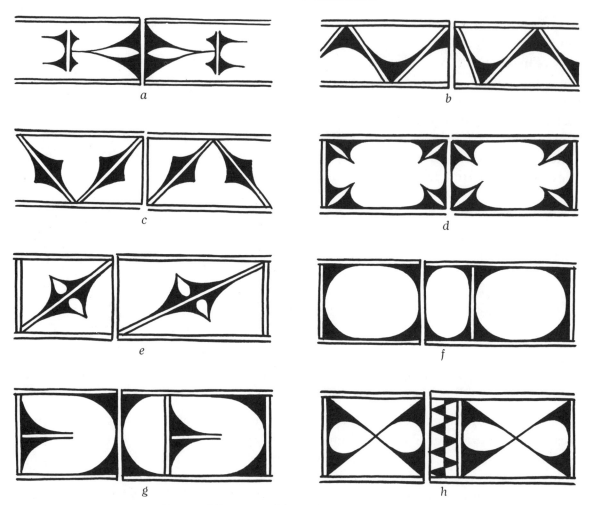

FIG. 31—Adjustments of decoration at the spirit path.

sion of the regular motif (*f*), a portion of the regular motif used in a reversed position to produce balance on both sides of the path (*g*), and an entirely distinct motif (*h*).

In bowls and jars with a single decorated zone the bordered path often appears as a most conspicuous and incongruous element, especially when motifs and arrangements are used in which no other long verticals appear (fig. 30, *c*).

Mention of the break in the wide black rim stripe has been reserved until the last for the reason that the stripe is the last detail of painted decoration to be applied to both bowls and jars. This is due to the fact that in handling the vessel during painting, the moisture from the palm of the left hand would soften the *guaco* pigment and blur the painting of the stripe. Since the rim of the jar receives the greatest wear, it is not always possible to determine whether a break has been left in the stripe. However, it appears in a great majority of the many

specimens examined, though not always directly above the line breaks in the decoration.[1]

EXPERIMENTS WITH NEW ELEMENTS AND ARRANGEMENTS

Only a few designs in the entire collection indicate a tendency to experiment with new ideas. Most notable are the six shown in figure 32. Familiar Santo Domingo elements appear in each, but the addition of extraneous elements, or the use of new arrangements, gives the group an unfamiliar appearance. Other obvious experiments are shown in plate 44, *b,* and in the group of designs in plate 45.

Fig. 32—Experiments with new arrangements.

INFLUENCE OF DECORATIVE SYSTEMS OF OTHER PUEBLOS

Lying as it does within such a large group of pueblos of the Rio Grande area, it might be expected that the art of the Santo Domingo potters would have been affected by the decorative styles of other pueblos, for considerable quantities of the pottery of each have been spread by trade or gift, and particularly during the past fifty years since travel between pueblos has been made increasingly safe and convenient for Indian women.

But, in spite of better communication, the impress of decorative ideas of other pueblos is found to be almost negligible. The closest resemblance is that between

[1] It is barely discernible in a few of the figures of plates 1 to 6, inclusive, but is shown clearly in several of the drawings of plates 7 and 8.

the wares of Santo Domingo and the neighboring pueblo of Cochiti,[1] though this is due largely to the use of almost identical ceramic materials. A few simple geometric band designs appear to have been for some time a common heritage of both pueblos, but aside from these the decorative systems of the two are quite distinct. The water jars of Tsia pueblo[2] have long been in favor at Santo Domingo and while it is possible that the idea of plant and bird motifs may have been suggested by familiarity with these motifs of Tsia ware, there is but little evidence of direct copying. There is, however, evidence of an unaccountable interest in the decorative system of pottery from the more distant pueblo of Zuñi.[3] The type of bird in plate 44, *i* is distinctive of that pueblo. It is used in the neck band of a Santo Domingo water jar, and below it are placed the volutes shown in plate 33, *c*. These as well as other volutes in plate 33, and that in plate 44, *o* are also characteristic of Zuñi decoration. The motif placed above the bird in plate 44, *n*, as used by the Zuñi potters, is known as a butterfly arrangement, though it functions usually as the "house of the deer," since it is commonly used to span a stylized figure of that animal. The designs have not been copied literally, for the Santo Domingo potters with their comparatively crude brush technique cannot cope with the finer details of Zuñi decoration. Yet in some instances there is an evident attempt to follow the Zuñi system of heavy and light lines. These instances of copying are so rare that they suggest the work of possibly only one potter. One other figure (pl. 58, *f*) is clearly a crude copy of a typical bird from Acoma pottery,[4] with detached wing and crest, and symbolic devices in its body.

It has been suggested that the Pueblo potters may have derived their vegetal and bird motifs from observation of similar designs in Majolica ware, embroideries, and other crafts available in early times at the Spanish missions, or in homes of Spanish families.

While the two broad concepts may have been derived from such sources certainly the potters of Santo Domingo have long made use of such ideas in their own way, as is shown in the plates which follow. More intensive studies now being made of the origin of these and certain other motifs should throw much needed light upon this phase of Pueblo pottery decoration.

SEQUENCE OF PLATES

It has been necessary to choose one of several methods of approach in determining a sequence for the figures in plates 7 to 62, inclusive. A chronological sequence would be most desirable, but as has been explained, there are insufficient data to warrant an attempt at such a grouping. A similar difficulty is encountered in building up a sequence of motifs from simple to complex, or in giving straight line forms precedence over those in which curved lines are used, for we must bear in mind that Santo Domingo design did not spring spontaneously

[1]Chapman, 1927, p. 209; and 1933, pls. 32-37.

[2] *Ibid.*, 1927, p. 210; and 1933, part 2, pls. 51-59.

[3] *Ibid.*, 1927, p. 212; and 1933, part 2, pls. 80-90.

[4] Bunzel, 1929, plate X, and Chapman, 1927, p. 211.

from a few simple elements and arrangements, but rather that its heritage from pre-Spanish times was as varied and as complex as that of any other pueblo.

Since arrangement is such an important factor in Santo Domingo design, the drawings have therefore, with few exceptions, been grouped according to the disposition of their elements as outlined under Arrangements (p. 22). However in considering such distinctive motifs as volutes, plants, and birds, it has been found more convenient to group these separately regardless of their arrangement, to facilitate a comparison of their details.

THE DRAWINGS OF PLATES 7 TO 62, INCLUSIVE

It is impossible to give the exact scale of reduction in the sizes of drawings in plates 7 to 62, inclusive, since many were sketched from pots from which measurements could not be made. They may be considered to average between one-third and one-fifth natural size.

Three repeats of the units of each design are used in most of the drawings of plates 7 to 45, inclusive. Extremes of variation in the proportions and details

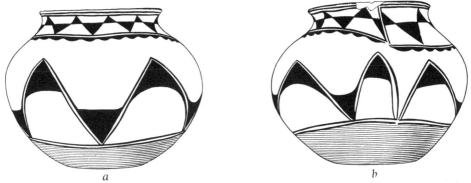

a *b*

Fig. 33—Distortion of decoration. Two opposite views of the same jar.

of units have been avoided, for these in many instances would distract from the purpose of this comparative study of design. Erratic proportions are often scarcely noticeable in the repetition of a design as it appears upon a pot itself, for but little of it can be viewed clearly from any point, and even that which can be included in any one view is modified by perspective and by its relation to the contours of the convex surface upon which it is placed. This is quite evident in figure 33 in which a degree of regularity (*a*) and an extreme of irregularity (*b*) are shown in opposite views of the same jar. Therefore, only a slight variation has been maintained in the details of each unit, sufficient to preserve the free hand character of the originals as they appear upon the pots themselves. Much of the effect of these intentional variations, however, is minimized by reduction of the drawings to the size of the printed plates. In considering these, therefore, it should be borne in mind that the average of technique in drawing must be determined by reference to the actual qualities of similar designs as they appear in the photographs used in plates 1 to 6, inclusive.

Plates 7 and 8. Bowls with interior decoration. The extreme rarity of decoration applied to the interior surface of bowls may be judged by the fact that only twenty-three specimens have been recorded. These, occurring in both the flaring and straight rimmed types, are illustrated in plate 1, *g,* and in plates 7 and 8. The designs are used in both food and utility bowls (see p. 9), but more frequently in the former. Those from utility bowls are figured in plates 7, *a, c, i,* and *j*; and in 8, *h,* and *k.*

Six designs are used in the interiors of bowls having an exterior finish of polished red slip (pl. 7, *a, d, h;* 8, *k, l*). Eight others appear in bowls having exterior decorations on the cream slip. The remaining eight designs in the two plates were drawn from sketches, tracings and photographs without notes as to exterior decorations.

There is no correlation between the motifs of the interior and exterior decorations, as may be seen by comparing the following figures of plates 7 and 8 with those of their respective exterior designs, as indicated in parentheses: plate 7, *b* (pl. 15, *m*); *f* (pl. 29, *h*); *g* (pl. 20, *i*); *i* (pl. 23, *h*); *j* (pl. 17, *i*); plate 8, *a* (pl. 52, *d*); *d* (pl. 22, *i*); *h* (pl. 29, *g*). An analysis of the designs of plates 7 and 8 is given on page 42.

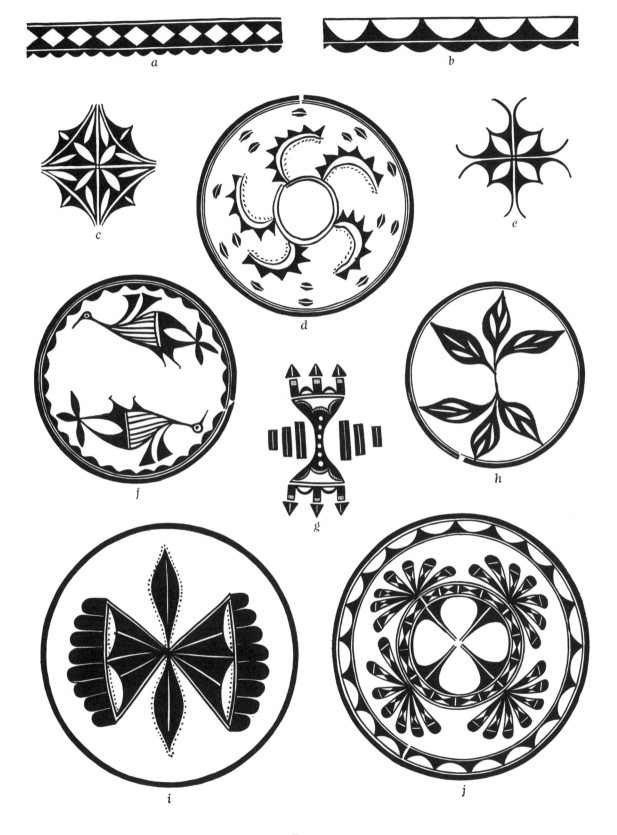

a

b

c

d

e

f

g

h

i

j

PLATE 7

Plates 7 and 8. Interior decoration of bowls. The arrangement of interior decorations shows but little conformity with the well organized system of exterior decoration of both bowls and jars, pointing apparently to late or desultory attempts to organize design in a new field. As has been noted (p. 15) this is doubtless due in part to the frequent use of an interior finish of polished red, upon which the *guaco* pigment does not burn to a good dense black.

The most constant decorative feature of bowl interiors is the border, placed immediately below the rim band. In some instances this constitutes the sole interior decoration. Such borders occasionally consist of a mere single or double line (pl. 7, *h, d*) or a wavy line (pl. 8, *e*), but more frequently the cloud motif is used (pl. 7, *f*). The cloud is used also as a lower border of wider bands (pl. 7, *a, b*; pl. 8, *f*) of the type commonly used for the exterior decoration of bowls and jars. With the exception of the border, the arrangements most favored for the decoration of the interior are those centered at the bottom of the bowl and usually separated from the border by a considerable space. These consist of designs developed upon crossed paired lines (pl. 7, *c, e*), repetitions of four, eight, or more identical units radiating from the center (pl. 8, *g, k, l*), an alternation of major and minor units radiating from the center (pl. 8, *a, d*), and arrangements of four to six units grouped about the center (pls. 1, *g*; 8, *h-j*). An elongation through one axis is found in three centrally placed motifs (pl. 7, *g*; 8, *a, c*). Only two of the centrally placed designs are so extended as to cover the major part of the interior. In one (pl. 7, *d*), the arrangement is crudely painted, but in the other (pl. 7, *j*) a fair degree of symmetry is produced in the quadrate arrangement of details both within and without a circular band.

Static arrangements prevail in most of the centered designs. In contrast with these is the marked whirling effect in two (pl. 7, *d*; 8, *k*). In three specimens (pl. 7, *f, h*; 8, *b*) pairs of motifs are placed at opposite sides of the interior. The bird and leaf figures (pl. 7, *f, h*) are included in other plates (59, *d*; 48, *o*) in which motifs of this nature are grouped for special consideration. The spirit path appears in the border of every bowl, but is omitted in the rim bands of three (pl. 7, *i, j*; 8, *d*). In some of the drawings the apparent width of the rim band is greater than the actual thickness of the rim itself, since the black band spreads downward somewhat into the interior of the bowl.

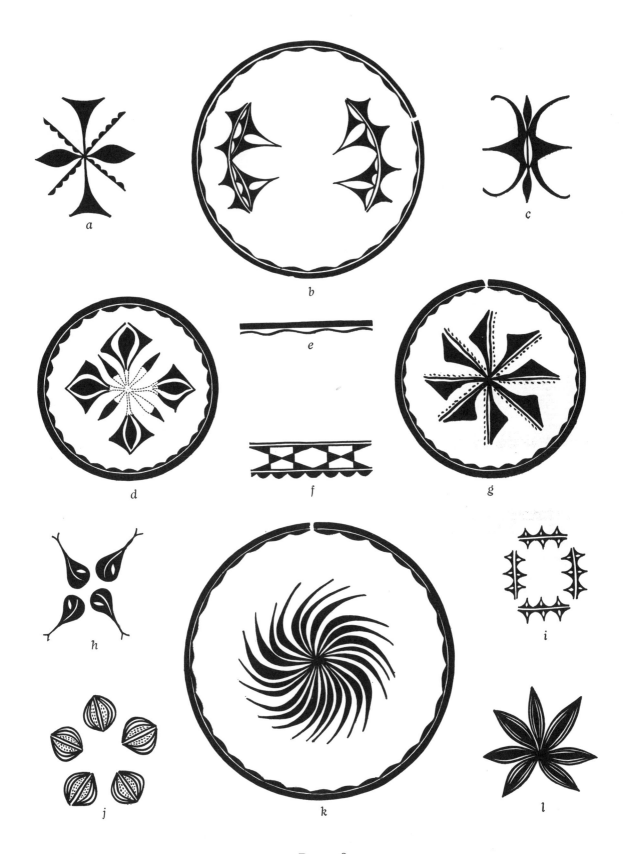

a

b

c

d

e

f

g

h

i

j

k

l

Plate 8

43

Plate 9. Elements and motifs either detached or adjoined, repeated in horizontal sequence, and not touching banding lines. Simple detached or adjoined motifs such as those in plate 9 are, theoretically, the most elemental of all Santo Domingo design arrangements. But it must not be assumed that the decorative art of Santo Domingo has developed progressively from such a simple source. This is clearly refuted by the comparative rarity of such simple forms in the pottery of the earlier period and their profusion in that of the past thirty years. Such detached motifs as those in the first column are commonly placed upon the necks of jars. In the drawings the banding lines are shown only where they closely border the motifs. Static arrangements predominate in the group of detached motifs. In contrast with these, the oblique arrangement of units in figure *b* gives an appearance of motion to the right. In *c* the effect is zigzag. There is practically no alternation of contrasting forms of simple detached motifs in Santo Domingo art; this alternation is confined almost entirely to the use of large and comparatively complex detached motifs such as plants and birds (pls. 1, *g*; 4, *b, c*). In the series of adjoined units (*l-s*) a repetition of like forms appears less frequently than an alternation of unlike motifs (*o-s*). Oblique arrangements of details occur frequently within the rectilinear units of this latter group (*p-r*).

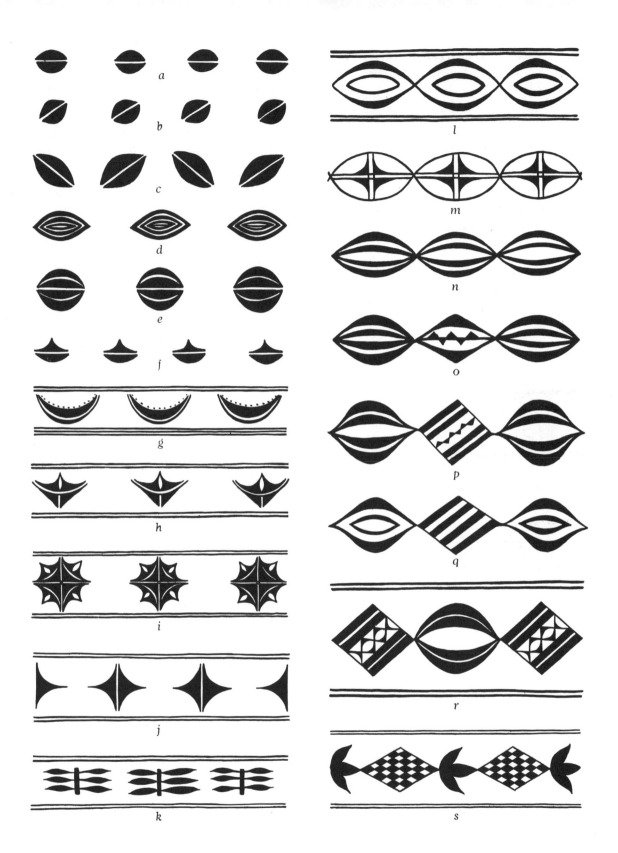

PLATE 9

45

Plate 10. Bilaterally symmetrical units in sequence, attached to one banding line. As in plate 9, many of these more simple forms appear on pottery of comparatively recent make. Figs. *a* and *b* are the only examples thus far found of the simple device of triangles used as repeated units in a band. A progressive embellishment of the paired and double cove appears in others (figs. *h-r*). Included in this plate for convenience are two figures (*f, g*), in which double rows of units are used.

In most of the figures (*a-p*) the units are more or less closely adjoined. In only two (*q, r*) are appreciable spaces left between units. This wider spacing is found more frequently in such band arrangements as those in plate 11.

PLATE 10

47

Plate 11. Bilaterally symmetrical units attached to both upper and lower banding lines. In eleven figures (*a-k*) opposed rows of motifs are spaced alternately above and below. This alternation tends to produce a wider horizontal spacing of the units than that used in the single rows of plate 10. In one (*b*) the black double coves extend nearly full way across the band, but each is carefully drawn to leave a slight open space between the point and the opposite banding line, thus making the design quite distinct from those in plate 27, *a* and *b*. In six examples (*b-g*) the upper and lower units are identical in form; in four (*h-k*) they are unlike. Two of these (*h, i*) have details which break the usual bilateral symmetry of the lower units. In the remaining figures (*j-q*) the motifs are in single rows, as in plate 10, but here they extend entirely across the band.

a

b

c

d

e

f

g

h

i

j

k

l

m

n

o

p

q

PLATE II

49

Plate 12. Unbalanced units in sequence, attached to one or both banding lines.
As noted in the discussion of static and dynamic forms (pp. 26, 27), the unsymmetrical motifs are used much less frequently than the balanced forms (pls. 10, 11). In six (*a-f*) there is a repetition of the same unit, attached to one line only. In one (*j*) there is an alternation of two motifs, and in another (*n*) an alternate inversion of the one motif. In three (*a, j, m*) rudimentary volutes are used. These, so common in the pottery decoration of other pueblos, are exceedingly rare in Santo Domingo design. More developed forms of the volute are grouped in plates 33 and 37. Four designs (*g, h, o, p*) are the only examples of transverse arrangements of V's and zigzags within bands.

a

b

c

d

e

f

g

h

i

j

k

l

m

n

o

p

PLATE 12

51

Plate 13. Zigzag arrangements. Plates 13, 14, and 15 give evidence of the importance of the zigzag in Santo Domingo decoration. This might be classed both as a motif and as an arrangement. It is more conveniently grouped with the latter because of its structural simplicity, which makes it an inviting form on which many familiar decorative motifs are used. There is no example of a plain, detached zigzag drawn with either single, double, or multiple lines. The zigzag crossed by a median line (*a, f*) is occasionally found as a filler of smaller spaces (pls. 30, *m*; 49, *q, t*; 52, *j*; 58, *d*). In plate 13, more or less ornament is used on each of four detached zigzags (*a-d*) of which two are drawn with single, and two with double lines. Following these are seven designs (*e-k*) in which a single line zigzag is attached to the banding lines. In *l* a continuous space is maintained between the paired lines of a zigzag which is crossed by painted horizontal lines. In the four remaining figures (*m-p*) the zigzag is not continuous; instead, the semblance of a true zigzag is obtained by drawing pairs of alternately right and left oblique lines across the band. This process interrupts the continuity of the open space between the paired lines, such as is maintained in *l*. In all the figures of plate 13 the original zigzag is subordinated more or less by decoration. In *j* it is halted by verticals and becomes merely the boundary of the resulting black triangles. In *k* the zigzag is all but lost in a crude arrangement of open leaf and disc spaces within a meandering form of black.

PLATE 13

53

Plate 14. Zigzag arrangements, continued. In figures *a-i*, as in plate 13 (*m-p*), decoration is concentrated upon the paired oblique lines themselves. In *g* the points of the double cove are carried to the banding lines, thus further subordinating the zigzag motif. In *j* and *k* the decoration is placed in the angles between the pairs of oblique lines. In *l* to *o* it is used in all the angles of each triangular space. The resulting adventitious background spaces are unusually conspicuous. They are considered in connection with other similar forms, (p. 27.)

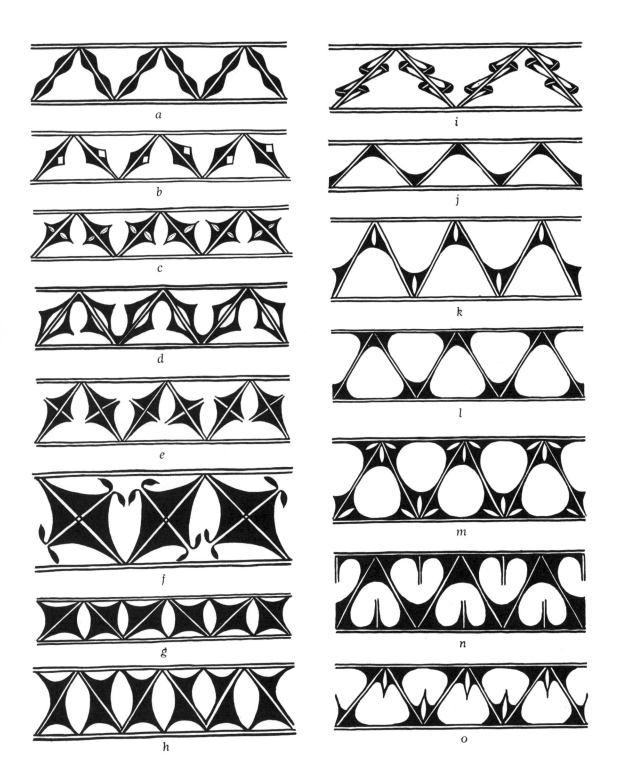

a

b

c

d

e

f

g

h

i

j

k

l

m

n

o

PLATE 14

55

Plate 15. Zigzag arrangements, continued. More complex decoration appears in many of the figures of plate 15. In two (*h, i*) the space between paired zigzag lines is partly continuous. There are four in which triple lines are used. In *k* there is an unusual instance of a zigzag motif crossing the triple lines of the larger arrangement. In *n* curved lines are first drawn from the upper and lower banding lines, and the intervening space is then filled with black, giving the effect of a pseudo zigzag. The introduction of unusual motifs within the open spaces marks this as an invention without traditional value.

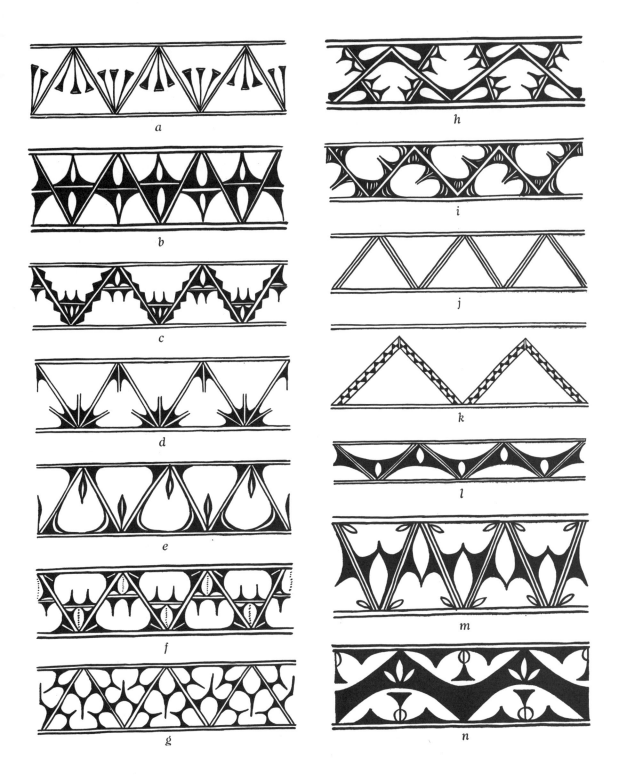

a

b

c

d

e

f

g

h

i

j

k

l

m

n

PLATE 15

57

Plate 16. Crossed zigzag arrangements. In thirteen figures (*a-m*) zigzags crossing each other produce rows of attached diamond spaces. Although it is possible to construct this design by drawing first one extended zigzag and then crossing it with the other, it is usually made by drawing a series of connected X's. In two (*a, b*) the zigzags are free. In *c* they depend from the upper banding line; in the ten succeeding figures (*d-m*) they touch both upper and lower lines. There is a balance of details above and below the middle of most of the figures. In three, however (*b, c, l*), the balance is not preserved. In all these the zigzag lines are more or less subordinated by partly or completely filling the resulting spaces with black. The continuity of the original zigzag lines is best discerned in such figures as *f-j,* and least of all in *m* in which the black triangles and open diamond spaces are dominant. Bilateral balance is preserved in the entire group, with one exception (*d*). The last two designs (*n, o*) are produced by crisscross lines which are not connected to form continuous zigzags. The resulting intervening spaces are hexagonal.

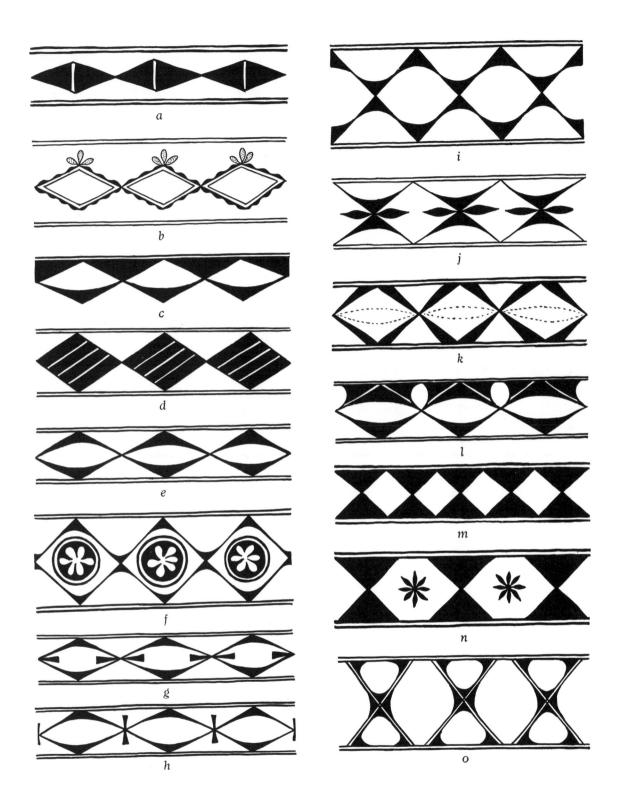

a

b

c

d

e

f

g

h

i

j

k

l

m

n

o

PLATE 16

59

Plate 17. Complex designs developed from crossed zigzag arrangements. The zigzag and crisscross arrangements such as those in plate 16 are maintained in this group, but the designs are made more complex by the use of either horizontal or vertical lines within the bands, or by combinations of the two. Horizontals alone appear in three of the figures (*a-c*), and verticals alone in five (*j-n*), while the two are combined in the group of six (*d-i*).

The crossing of continuous zigzags is maintained in only five of the fourteen figures (*a, b, j, k, l*). In *d* and *e* the zigzags, interrupted by the vertical paneling lines, are replaced by a crisscross in each panel. In these two the paneling is confused by the passing of the horizontal lines through the paired uprights. This produces three narrow vertical spaces, the middle of which is always solid black. In *f* the small upright zigzags interfere also with continuity of the horizontals which, like the crisscross, are confined to the panel spaces. Following are two modified forms in which paired coves, replacing the triangles, bear no relation to the small crisscrosses.

An unusual form appears in *i,* in which the crossed "V's" and the horizontals produce four minor, and six major triangles in each panel, the latter forming a six-pointed star. The basic construction of *j* and *k* is identical, the two varying only in their proportions. In *m,* since there are no horizontals crossing the paired verticals, the latter have seemingly no constructional value, though in fact they serve to confine the crisscrosses within the three panels.

In *n* the substitution of a bifurcated rectangle for the pair of triangles in *j* gives added prominence to the three hexagonal open spaces.

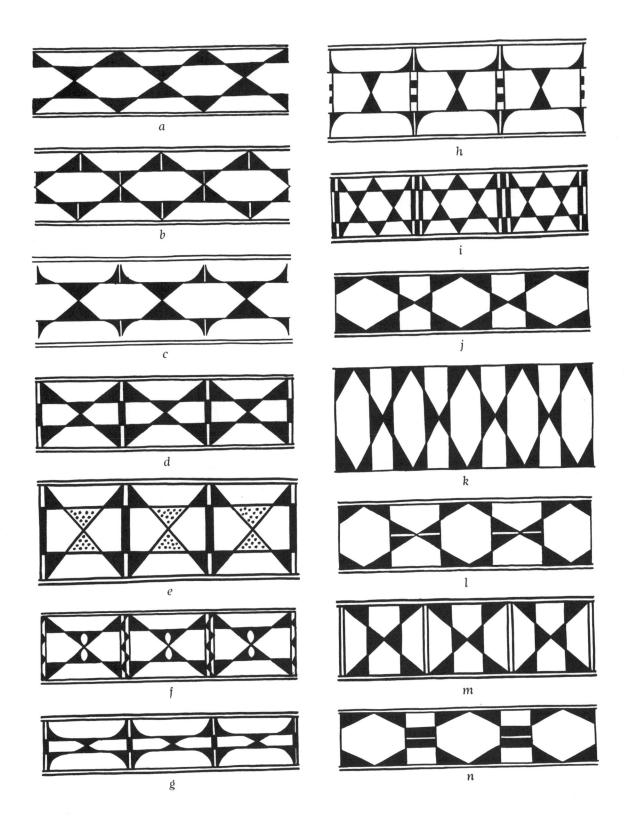

a

b

c

d

e

f

g

h

i

j

k

l

m

n

PLATE 17

61

Plate 18. Bilaterally symmetrical designs developed upon paired vertical lines within bands. An occasional division of bands into panels has been noted in a few figures of plate 17 (*d-g, i, m*). These, however, are confined to variations of the crisscross.

In plate 18, a greater variety in paneled motifs is shown in fourteen designs, each composed of repeated, bilaterally symmetrical units developed on pairs of vertical lines which divide the band into panels. In each of the five figures (*a-e*) three full panels are shown, thus providing two complete figures for comparison with the half figures at left and right. As seen in more extended bands, these dominant figures tend to obscure the effect of paneling.

Only one unit of the more extended motifs is used in each of the nine figures (*f-n*). In *c* the consistent use of diagonally opposed black spaces nullifies the bilateral symmetry of the dominant motifs. An unusual combination appears in *m*, which is one of two nearly identical arrangements in the exterior band of a large bowl. Here the usual paired paneling lines are replaced by a narrow panel enclosing a diagonally placed checker motif. The two parts of the major motif are unlike, but in the opposite figure (not shown) the lighter details at the left appear on both sides of the checkered panel.

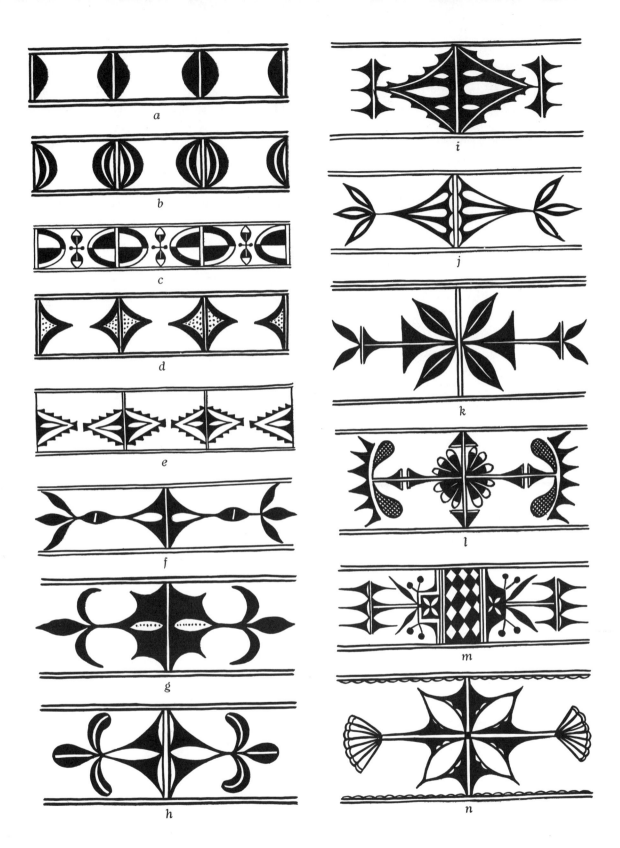

PLATE 18

63

Plate 19. Bilaterally un-symmetrical designs developed upon single or paired vertical lines within bands. Plates 19 to 22, inclusive, afford one of the best evolutionary series in the entire system of Santo Domingo decoration. Derived from an ancient motif of the pre-Columbian period (fig. 3, *f*), it survives in its simplest geometric form in plate 19, *a*. The verticals are drawn first and, crossing these, two oblique lines meet near the center of each rectangular space. The resulting "point" and the other two triangular spaces are then filled with black, producing a figure of simple but striking form when used in repeats. Numerous examples of this type appear in neck bands of both antique and recent jars. These vary greatly in their proportions but all retain this simple rectilinear form. It will be noted that when two of the units of figure *a* are placed point to point, they produce a single unit of the motif in plate 17, *j*.[1]

Variants of the type with single verticals appear in figures *b* to *e*, inclusive. In *c* and *e* the straight oblique lines are replaced by curves. Following these is a much larger group, (*f-p*) in which paired verticals are used. These emphasize somewhat the effect of panels, yet attention is still centered upon the units of the motif itself even though they are bisected by the paired lines. In all of these paneled forms coves are substituted for the black triangular spaces of *a* and *b*. Six variations of the use of bifurcated "points" appear in figures *k* to *p*, inclusive, and many other examples are to be found.

[1] For a more systematic study of this and many other motifs in this volume, see Shepard, 1948.

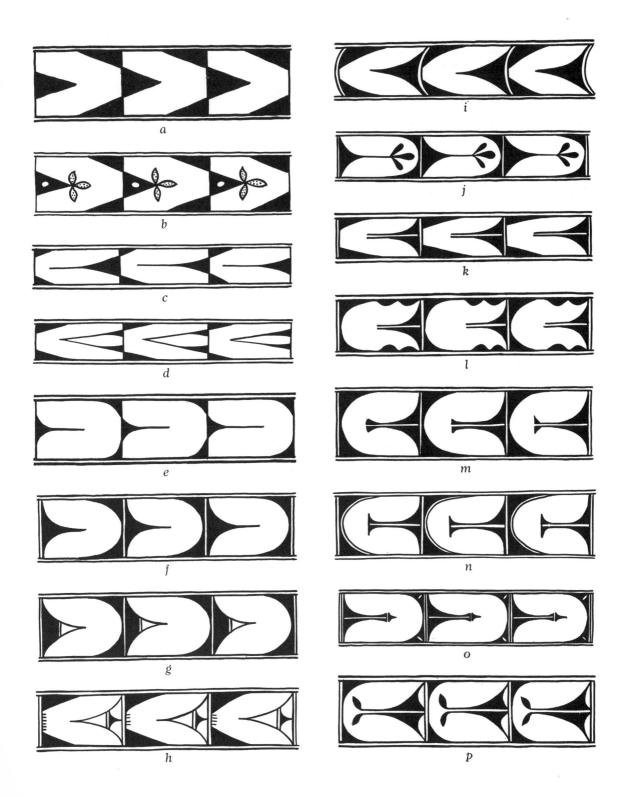

a

b

c

d

e

f

g

h

i

j

k

l

m

n

o

p

PLATE 19

Plate 20. Further evolution of the series in plate 19. The bifurcation of the "points" noted in plate 19 is continued in seven figures of plate 20 (*a-g*). The original straight line form of plate 19, *a* survives in part in the triangles of four figures (*c, g, o, p*). In *h* an additional motif appears which outweighs the original motif itself.

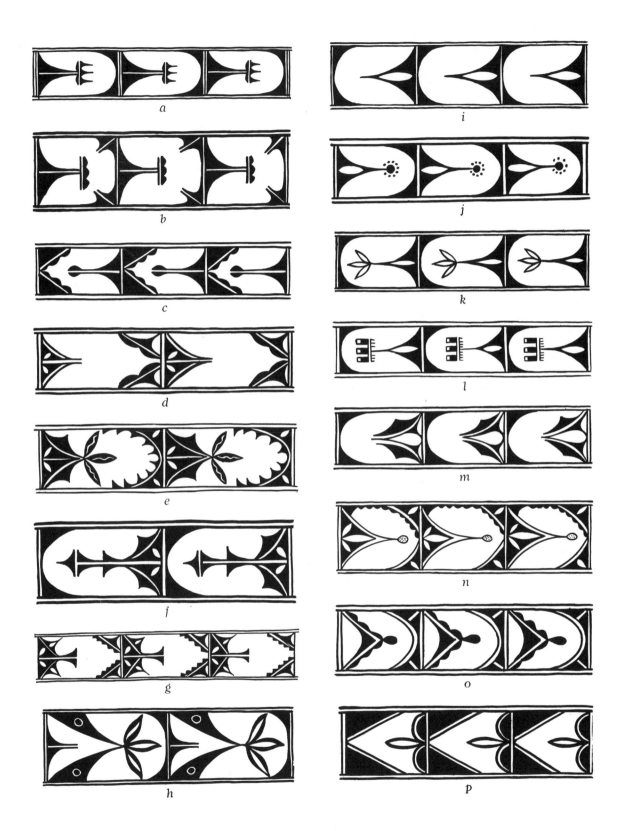

a

b

c

d

e

f

g

h

i

j

k

l

m

n

o

p

PLATE 20

67

Plate 21. Further evolution of the series in plate 19. Double and triple "points" appear (*f, e*). Following these are ten designs (*g-p*) in which the point is replaced by double or multiple parallel stripes which, in some instances at least, may be interpreted as feathers (*m*). In these both straight and curved lines are used to outline the counterpart of the upper and lower triangles of the simple original form (pl. 19, *a*).

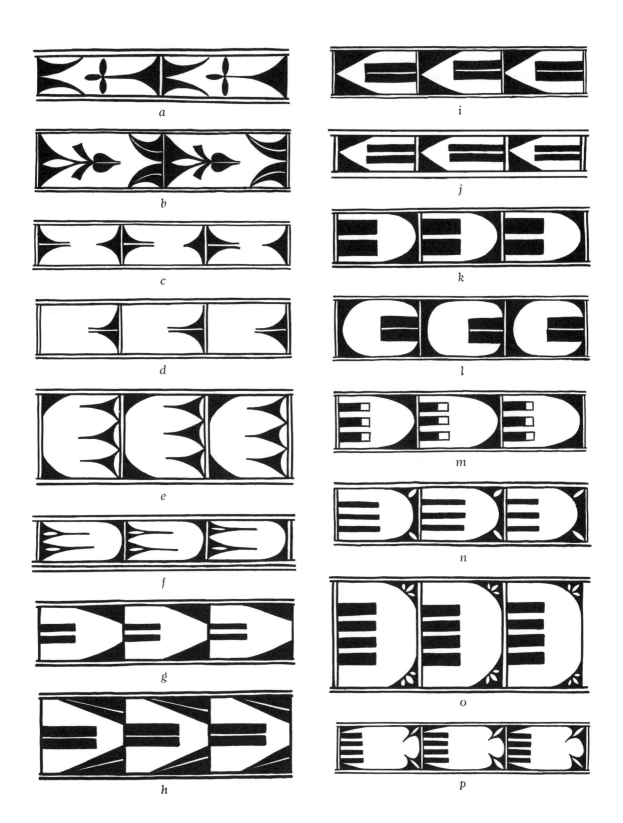

a

b

c

d

e

f

g

h

i

j

k

l

m

n

o

p

PLATE 21

69

Plate 22. Final development of the series in plate 19. In *a-k* the pair of triangles is replaced by a single semi-circular form with possible cloud symbolism. In *l* it is doubled. In *m* to *p*, and *r*, two *small* "points" are placed opposite the large ones. Other elements are used in *q*. In *r* the "points" are connected with the paired verticals.

In this and the three preceding plates the bands have been divided into panels by the use of paired verticals, or less frequently by single or multiple lines. In all of these, however, the panel concept is considerably obscured by concentration upon the units of design which are built upon the verticals. In contrast with these we find a large group of designs in which the panel concept is paramount. These are shown in the following eight plates (23-31).

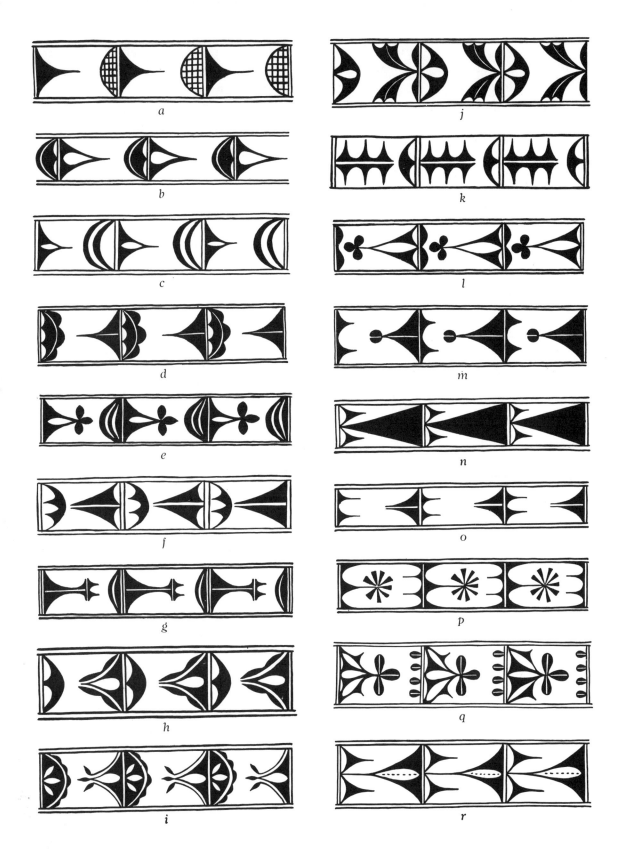

a

b

c

d

e

f

g

h

i

j

k

l

m

n

o

p

q

r

PLATE 22

71

Plate 23. Diagonals within panels. In plates 23 and 24, diagonals are used as the basis for the major decoration. In these the direction is preponderantly from upper right to lower left. In plate 23 the dominant decoration is placed upon the diagonals, though in *c* and *n* other elements share in importance.

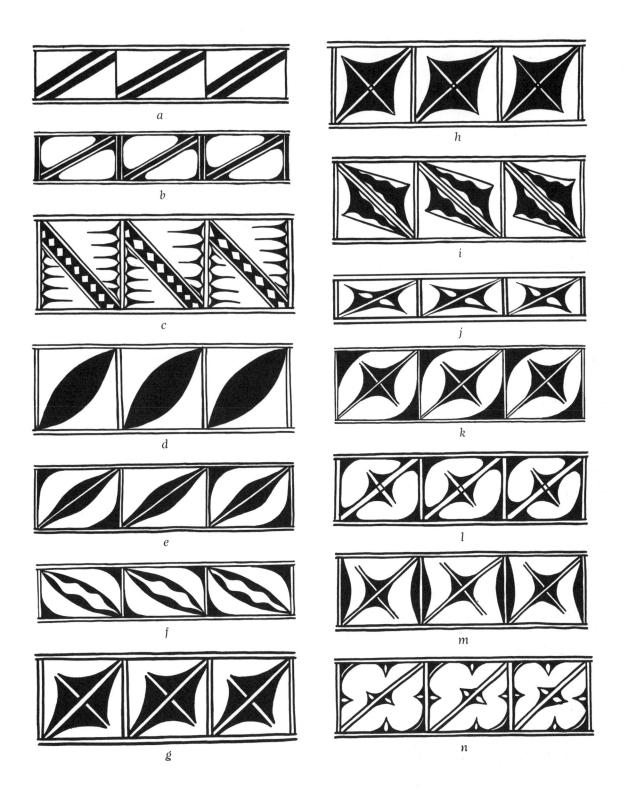

a

b

c

d

e

f

g

h

i

j

k

l

m

n

PLATE 23

73

Plate 24. Diagonals within panels. In plate 24, *a* to *g*, coves are used in corners opposite the diagonals. In four designs (*i, j, l, m*) decoration is placed in the angles between diagonals and verticals. In one (*k*) they are placed against the banding lines; in *o* two angles of each triangle are filled; in *n* no angle is left unfilled. In some of these (*l, m*) the diagonals are obscured by the attached decoration.

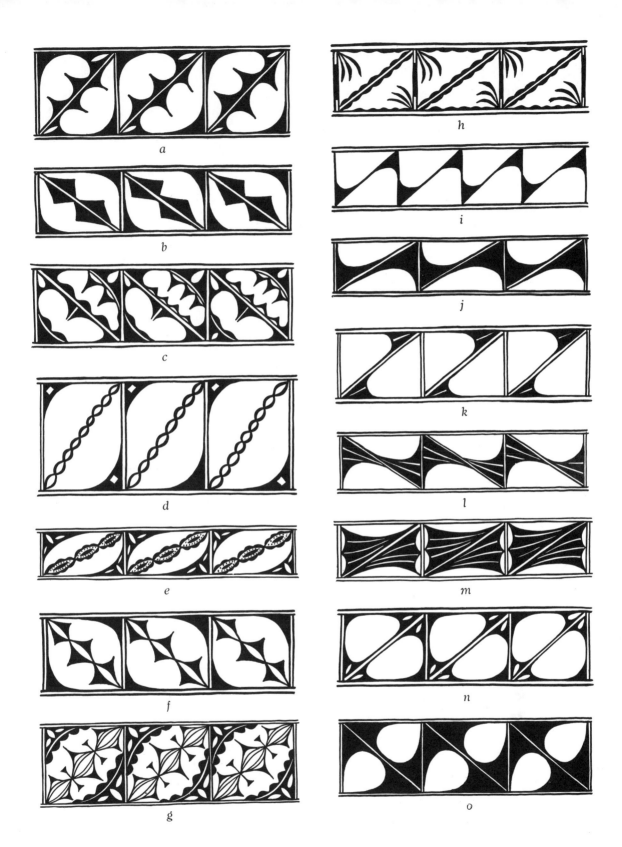

a

b

c

d

e

f

g

h

i

j

k

l

m

n

o

PLATE 24

75

Plate 25. Diagonals within panels. In this, as in the preceding plate, the diagonals in several figures are subordinated by various decorative devices. For example, in figure *c*, they appear as mere props to hold the heavier elements in place. In all the examples of plate 23, and except for *c* and *h* in plate 24, there is a balanced effect in each panel, so that the designs appear the same when inverted. The same regard for balance appears in figures *a, b, c,* and *g* of plate 25. In contrast, though the diagonal is preserved in figures *d, e,* and *f,* there has been no attempt at balance between the upper and lower triangles. In four designs (*h-k*) a leaf form with curved midrib takes the place of the diagonals. An alternation in the direction of the diagonals in succeeding panels gives the effect of a zigzag. In *m* and *n* this alternation also produces a pairing of the corner coves in adjacent corners, alternately upper and lower; an arrangement which is more commonly seen in panels without the diagonals (pl. 27).

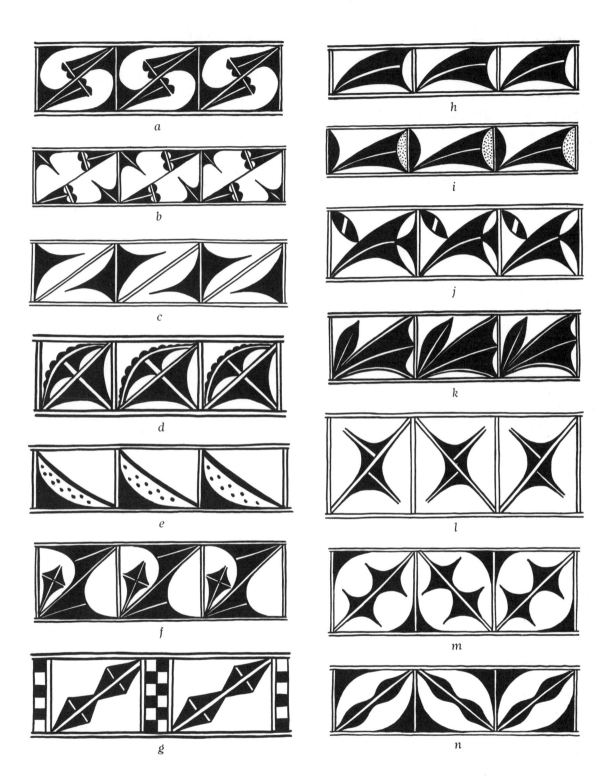

a

b

c

d

e

f

g

h

i

j

k

l

m

n

PLATE 25

77

Plate 26. Designs in diagonally opposite corners of panels. A diagonal effect within panels is maintained in plate 26 by the use of simple or ornate details in diagonally opposite corners. The cove, ranging from simple to ornate, is used in nine of these (*a-i*), and the triangle, more or less ornamented, in five (*j-n*). In several designs the interest centers not so much upon the contents of each individual panel, as upon the massed combined effect of pairs of adjacent black corner details placed against the single or paired verticals (*a, c, i, l*). Only one example appears with unlike units in diagonally opposite corners of panels (*n*).

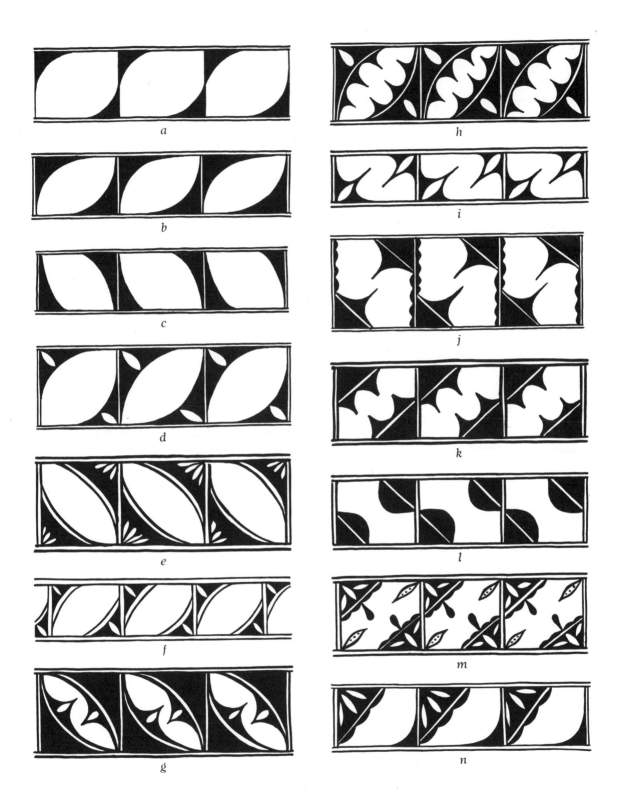

a

b

c

d

e

f

g

h

i

j

k

l

m

n

PLATE 26

79

Plate 27. Arrangements of corner designs within panels. A wavy arrangement of leaf-shaped background spaces is produced in *a* by shifting the position of the coves in alternate panels, so that they are paired alternately above and below. This simple arrangement continues through *b, c,* and *d.* In *e* two motifs of contrasting form appear in each panel. In the middle panel the large motif is in the upper left, and the smaller in the lower right corner. In the end panels, their respective positions are reversed to the lower left and upper right corners, producing an un-symmetrical grouping of motifs upon the paired verticals. In *f* the two contrasting corner motifs in the middle panel are shifted respectively from upper left and lower right to lower right and upper left, thus producing pairs of each in alternation upon the paired verticals. Following these are five designs (*g-l*) resembling somewhat a group of figures (*l-r*) in plate 10. But here, as in those above, the paneled construction is used. In three of these (*g, h, k*) a balanced effect is maintained, but in two others (*i, j*) the oblique elements are disturbing. The alternation of unlike units in *l* is quite unusual. The three remaining figures (*m-o*) offer striking examples of background spaces completely surrounded by black. It should be repeated however that in each the artists has concentrated upon the corner motifs in black and that the spaces are not as apparent upon the pots as they appear here in extended form.

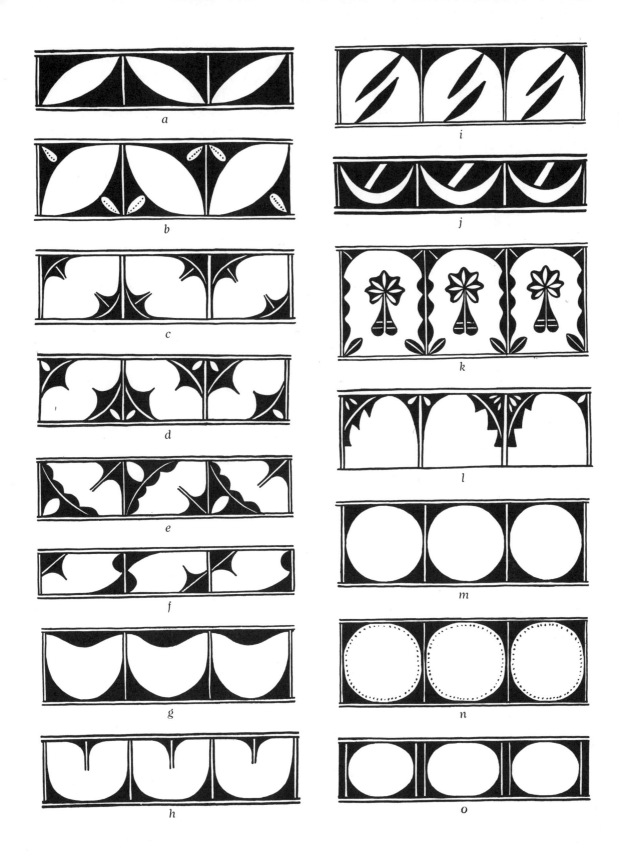

a

b

c

d

e

f

g

h

i

j

k

l

m

n

o

PLATE 27

81

Plate 28. Corner and other arrangements within panels. The comparatively simple designs in figures *m, n,* and *o,* of plate 27 are frequently used, but the more elaborate forms in plate 28 are rarer (figs. *a-j*). In only one (*a*) is there a straight line treatment of corner spaces In six others (*b-f, h*) coves are used. In *g* the open leaf spaces are symmetrically arranged. In *i* they alternate in corners with paired coves. These designs are made more complex by the addition of center motifs within the panels of *a, b, c,* and *d*; and of other details attached to the sides in *e, f,* and *h*. The number and position of single and double coves is irregular in *j*. Paired coves are used at the four sides of each panel of *k*. In *l* the solid coves are united. In *m* the points also unite at the center, but an unsymmetrical effect is produced by use of slender leaf spaces in two corners of each panel. In *n* small coves are added in the corners to produce rounded petal-like open spaces. As in plates 26 and 27, many of the figures in plate 28 are divided in interest between the motifs in black, and the open center spaces.

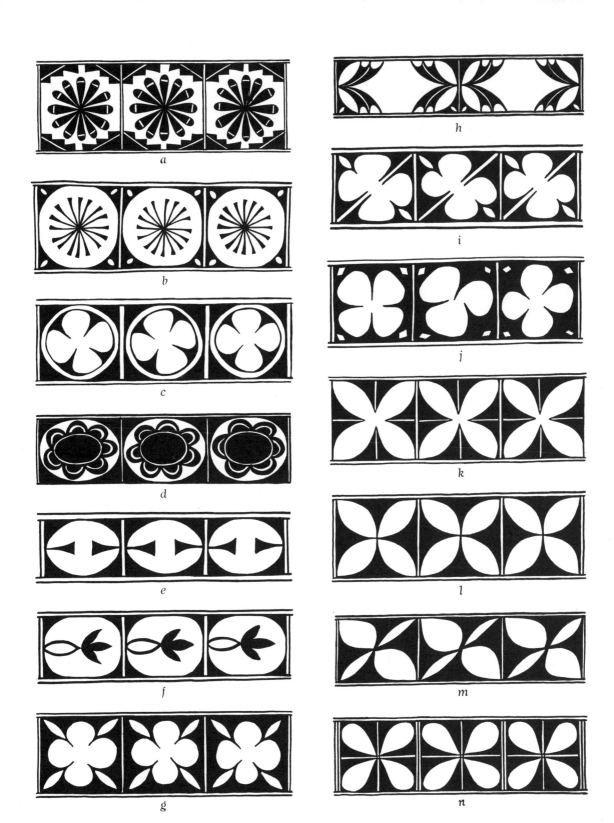

a

b

c

d

e

f

g

h

i

j

k

l

m

n

PLATE 28

83

Plate 29. Crossed diagonals within panels. In plate 29 crossed diagonals are used as the basis of a series of panel designs. The diagonals are composed of single lines and the decoration is confined mainly within the triangular spaces on either side of the verticals. In only three (*l, m, n*) is there additional decoration in the upper and lower triangular spaces.

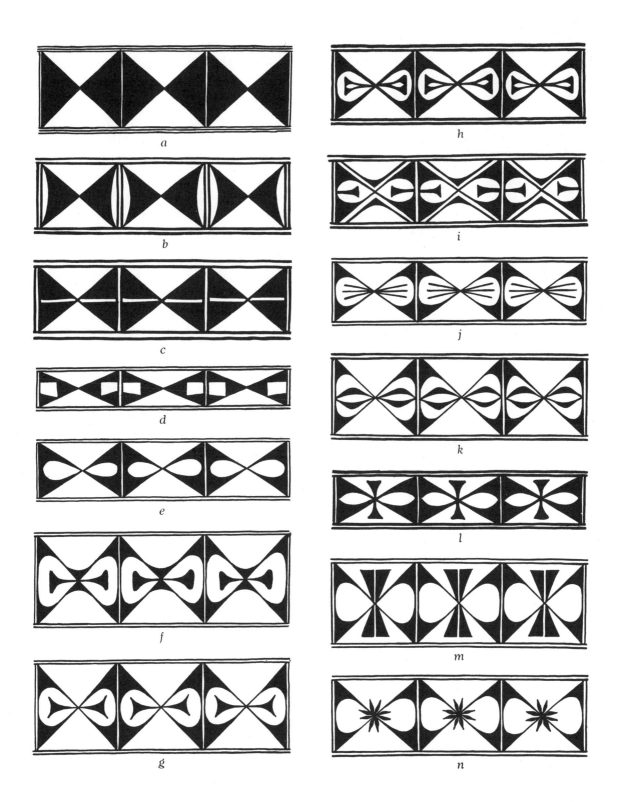

a

b

c

d

e

f

g

h

i

j

k

l

m

n

PLATE 29

85

Plate 30. Crossed single and double diagonals within panels. Crossed single diagonals form the basis of decoration within the panels of *a, b,* and *f.* In *a* the diagonals are paralleled above and below by secondary lines upon which the coves of the upper and lower triangles are placed. In *b* the diagonals are paralleled at the sides by similar secondary lines upon which the coves of the side triangles are placed. In the twelve other figures (*c-e, g-o*) the diagonal lines are paired. The difference between the basic construction of the two types is best understood by comparing *b* with *c.* An unusual arrangement occurs in *f,* by which each crisscross extends through two panels. Tiny coves are used to accent the intersection of the diagonals with the paired uprights. In *m* the zigzags within vertical bands compensate for the absence of coves in the panel corners. Only one example has been recorded of the type of design shown in *o.* This is produced by adding four curved lines extending between adjacent corners of each panel, and four others extending from middle to middle of adjacent sides. By this device each panel is divided into thirty-three spaces, of which sixteen are painted in solid black.

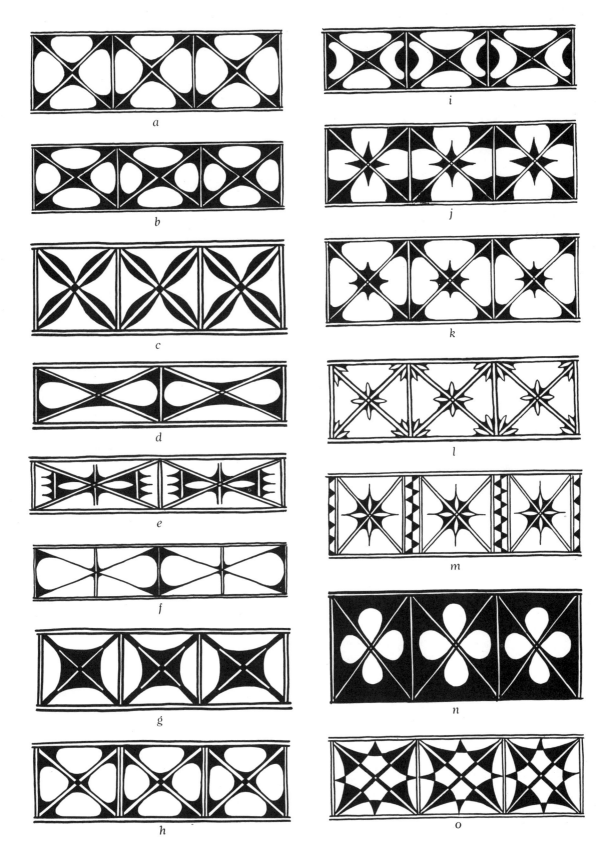

a

b

c

d

e

f

g

h

i

j

k

l

m

n

o

PLATE 30

87

Plate 31. Alternation of details in panels. The use of contrasting decoration in alternating panels is not common at Santo Domingo. Examples are given in plate 31, *a* to *l*. In *a, b,* and *c,* single verticals are used. In *b, c, k,* and *l,* the panels are alternately wide and narrow. While there is a semblance of alternation in *m* and *n,* actually the panels themselves are identical in every detail. In *m* only one and one-half panels are included, the complete panel at the left containing a unit of the geometric motif shown in plate 19, *a.* In *n* one unit of the balanced geometric motif of plate 17, *m* appears in each panel. Two interpretations may be given to the construction of *m.* This may be considered as three panels, separated alternately by single and paired verticals, or as one and a half panels, the whole long panel containing at its middle a unit of the motif shown in plate 19, *a.* In like manner *n* may be considered as comprising six panels separated by paired verticals and each containing at its middle a unit of the motif shown in plate 17. In the latter case, in both *m* and *n* the successive long panels are identical in contents and arrangement, but the effect of panels is decidedly subordinated by an apparent alternation of motifs.

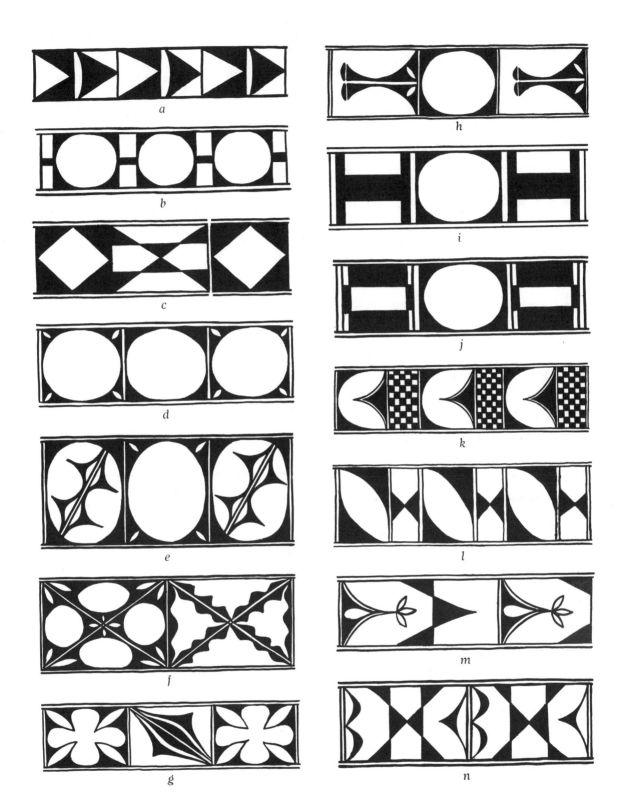

PLATE 31

89

Plate 32. Units developed upon paired or multiple oblique lines within bands. Such arrangements are somewhat rare. Paired or multiple oblique lines are used to divide the bands into rhomboid spaces. Among these are only two examples (*c, l*) in which the oblique lines are drawn from upper left to lower right. There is a similarity of details on both sides of the oblique lines in all but four figures (*e, f, g, m*). In *a* to *g*, and *n*, the major decoration is developed on the oblique lines. In *h* to *l* it is placed in the corners of the rhomboid spaces. In *m* decoration is used both on the oblique lines and in corners. In most of the figures interest is centered upon the motifs in black, developed upon the oblique lines, for the inter-spaces attract but little attention. A certain degree of interest, however, develops in the simple space forms of *h* to *m*. This is due to the use of considerable black in the corner spaces surrounding them. There is only one example (*n*) in which the black is so used as to center the interest within the rhomboid spaces.

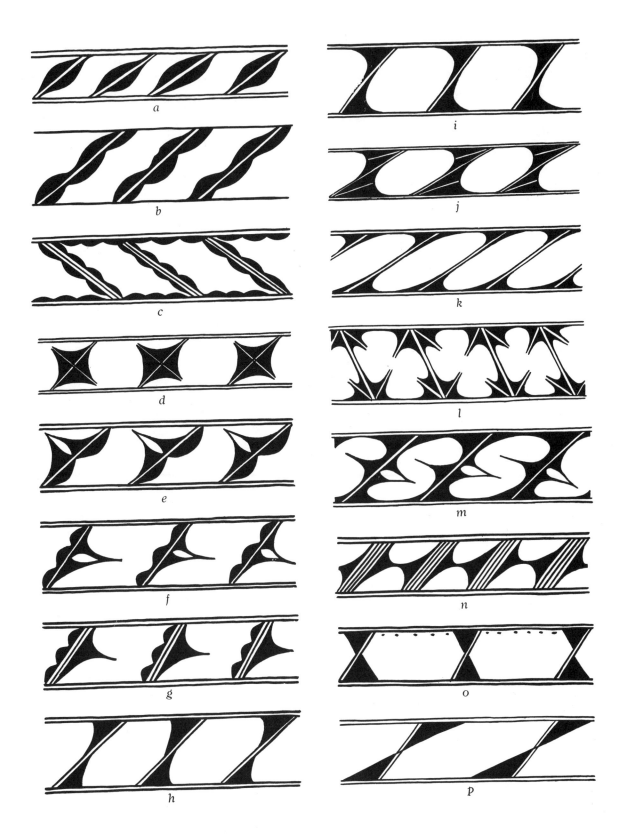

a

b

c

d

e

f

g

h

i

j

k

l

m

n

o

p

PLATE 32

Plate 33. Volutes. The volute is rare in Santo Domingo decoration. Three examples, used as appendages of larger motifs, have already been noted (pl. 12, *a, j, m*). Plate 33 contains fourteen more dominant examples of the motif. These might have been included in other plates according to their use, for they appear attached to banding lines, within panels, and in other arrangements. For example, *g* might well have been included with the rhomboid paneled spaces of plate 32. However, it has been found more expedient to group them in one plate for convenience in comparison. All of these are composed of two lines and, with one exception (*n*), all bear upon their outer curves, triangles or double coves in solid black or in hachure. In *m* and *n* the double coves are so attached that they project inward, thus permitting close spacing between the sigmoid units. Figures *l, m,* and *n* are the only examples of the sigmoid motif encountered in Santo Domingo art. Five other arrangements of volutes appear in plate 37.

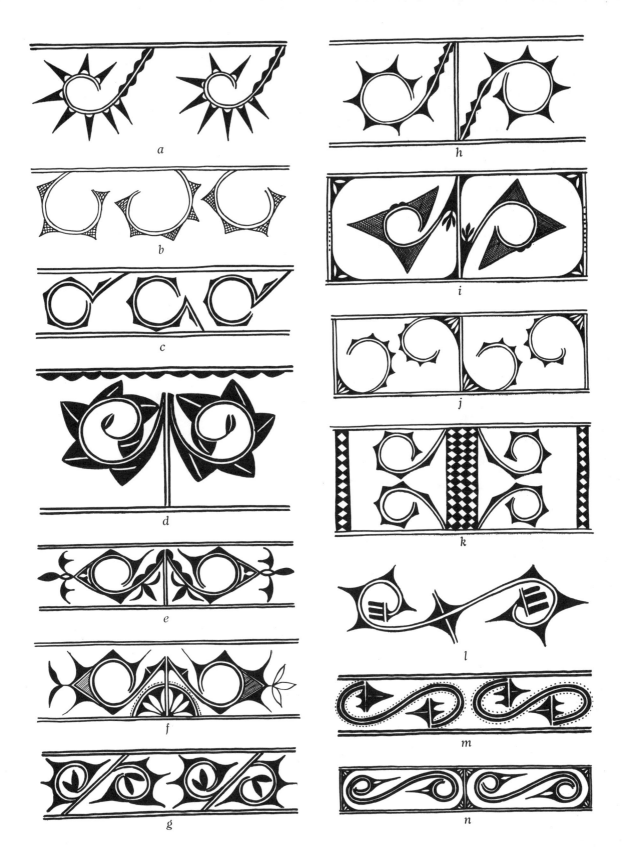

a

b

c

d

e

f

g

h

i

j

k

l

m

n

PLATE 33

93

Plate 34. Horizontally extended motifs both free and attached. Two or more of these are used commonly in the circuit of a jar. Where only two appear, these usually alternate with other motifs, some of which are shown in plate 35. The group is evenly divided between forms free from banding lines (*a-e*) and those which are attached (*d-j*). Leaves appear in *a, c, e, f, g,* and *i,* and flowers in *f*. The others contain elements similar to those in the upright forms of plates 53 to 56, inclusive. The bulbous device in several of the designs is used chiefly in this arrangement. Other examples are included in plates 40, *a*; 53, *b*; 56, *c*; and 61, *c*.

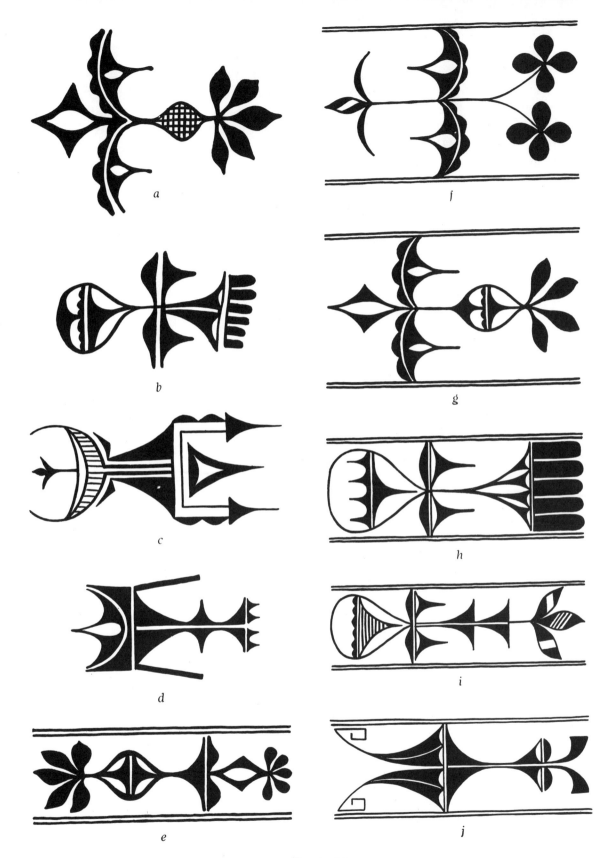

a

b

c

d

e

f

g

h

i

j

PLATE 34

95

Plate 35. Detached motifs used in alternation with others. These, frequently used in alternation with motifs of a more or less dominant type, are composed of the familiar elements which have made up the greater part of the decorative arrangements thus far shown. They differ from the detached motifs in plates 36 and 37 in that they usually appear between more dominant detached motifs. Except for *a* and *m,* all are bilaterally symmetrical. The swastika-like arrangement in *m* is most unusual.

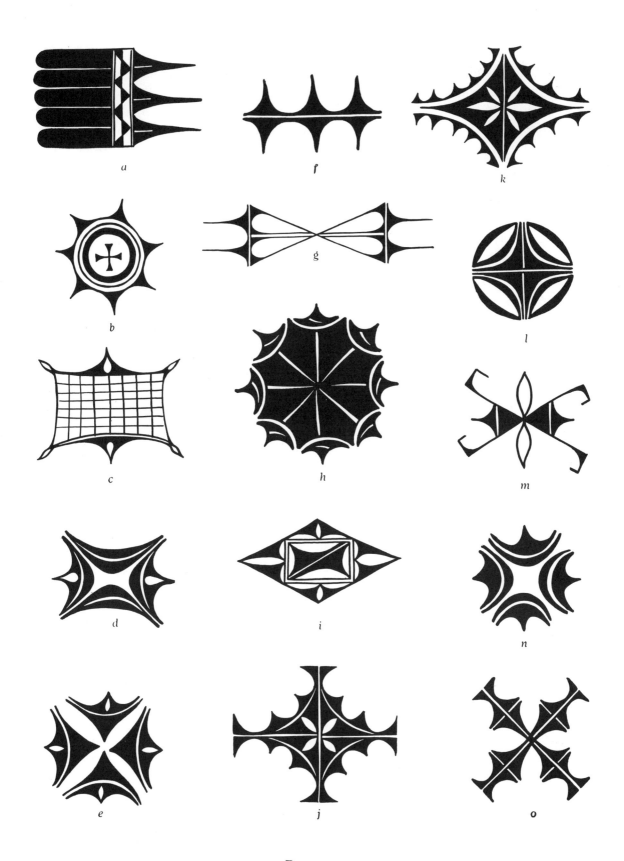

a

f

k

b

g

l

c

h

m

d

i

n

e

j

o

PLATE 35

Plate 36. Units placed obliquely in diagonally opposite corners of panels.
Plates 36 to 40, inclusive, contain designs which for various reasons were selected for reproduction on a larger scale than the preceding groups. In copying these, no uniform rule of arrangement was followed. Three drawings in plate 36 (*a, b, d*) include two whole panels, each design constituting one half of a band encircling a large storage jar. In each figure, the units placed obliquely in the upper right and lower left corners of the panels tend to draw attention from the panel spaces and to concentrate interest upon themselves as appendages of the paired verticals. This arrangement is comparable with that in plate 26, *i, j, k,* and *l.* An additional motif has been added to the middle of each panel, either attached to the lower banding line (*a, b*), or free (*c-e*). Those in *e* conform somewhat with the diagonal arrangement of the motifs in corners. The circle of each of the two discs in *d* is broken by a spirit path; the only instance of its use in a detached motif.

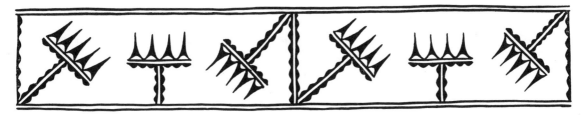

a

b

c

d

e

PLATE 36

Plate 37. Paired volutes. Here less than two thirds of each panel is shown in each of the five drawings. The volutes in *a* to *d* are attached to diagonally opposite corners of panels. This arrangement, as in plate 36, centers interest in the pairs of volutes, as appendages of the paired verticals. In *e* both volutes are drawn upward from the verticals. Additional motifs also appear in the middle of panels. In *a* they repeat the oblique arrangement of the volutes; in *b, c, d,* and *e,* they are static.

a

b

c

d

e

PLATE 37

Plate 38. Bilaterally symmetrical units upon paired verticals. One whole panel and parts of two others are shown in *a.* In *b* only two-thirds of two adjacent panels are included. In this there is an unusual crossing of the paired verticals by paired horizontals. In *c* two dominant motifs, similar to those in plate 22, but more widely separated, alternate with a smaller bilaterally symmetrical arrangement also placed upon paired verticals. The profusion of paneled designs in the many preceding plates would indicate that *d* includes two panels similar to those in plate 28, *a,* though by the use of paired verticals for the center motifs each panel has been subdivided. The stepped motif in the panel corners of *d,* though commonly used by other pueblos, is exceedingly rare in Santo Domingo design. One other example appears in plate 39, *a.*

a

b

c

d

PLATE 38

Plate 39. Miscellaneous paneled designs. In *a* like motifs are paired upon the paired verticals, to produce an alternation of unlike but equally important units. In *b* each of the two long panels is subdivided by paired verticals supporting a complex arrangement which is bilaterally symmetrical except for the diagonal open stripes on the "feathers," running uniformly from upper right to lower left. The panels are separated by an unusual feature of double vertical bands of oblique open leaf spaces. Such wide vertical bands are quite rare. Usually they are single, and contain arrangements of geometric details (pls. 25, *g*; 30, *m*; 31, *k*; and 33, *k*). Panels provide the basic construction in *c*, although the more lively interrupted zigzag dominates the design. Two directions of the paired obliques are used in each panel, an arrangement differing from that in three figures of plate 25 (*l, m,* and *n*). In all three figures (*a, b,* and *c*) the upper and lower details within panels are not identical. A corner arrangement similar to that in plate 28, *a* is seen in the three panels of *d*. Here there is a rare instance of a small detached motif used to balance an opposed detail. Figure *e* is of the class grouped in plate 18, with the addition of a cloud border at the bottom.

a

b

c

d

e

PLATE 39

Plate 40. Miscellaneous designs within bands. Several examples of flowers and leaves appear in plate 40. These motifs are considered in detail in the description of plates 46 to 52, inclusive. The balanced arrangement of *a,* like that in plate 39, *e,* is similar to the series in plate 18. In *a* appears a bulbous device, other examples of which are shown in plate 34. It is less frequently used between the body and tail of the Santo Domingo bird (pl. 61, *c*). In *b* the paired verticals support the exaggerated length of an unbalanced device comparable with that in *c,* and with the many other more simple forms in plates 20 and 22. In *d* a checkered square, placed diagonally, provides an unusual substitute for the paired verticals. Plant forms, shown in *e,* are seldom used in repeats.

a

b

c

d

e

PLATE 40

107

Plates 41 to 44, inclusive. Miscellaneous designs. These include drawings for which there was no space in the plates to which they would otherwise have been assigned, or that have been acquired since the plates were completed; and also designs which can not be classified satisfactorily with any group. The forms in plates 41 and 42 are static; in 43 and 44 nearly all are dynamic.

Plate 41. Miscellaneous static designs. Particular attention is called to certain designs in plate 41 which are related in their basic arrangement to those in preceding plates, shown in parentheses. These are: *d* (pl. 9, *l*); *f* (pl. 11, *h-k*); *j* (pl. 18); *n* and *o* (pl. 28, *g*); *p* (pl. 27, *m*). There is only a resemblance between *g* and plate 27, *a,* for in *g* two open leaf forms appear in each panel. Likewise *k* resembles plate 27, *m,* but its components are those of plate 11, *d,* with the upper and lower units opposed instead of alternating. In structure and arrangement *l* and *m* are unlike designs in any group.

PLATE 41

109

Plate 42. Miscellaneous static designs. Certain designs in plate 42 are more or less closely related to those in preceding plates. Compare the following figures with the plates given in parentheses: *a, b* (14); *d* (13); *e, j, k* (27); *f* (11); *l, n, p* (28); *m* (17); *o* (56). The significance of *g* is discussed under Symbolism (p. 32).

PLATE 42

111

Plate 43. Miscellaneous dynamic designs. Several of the designs of plate 43 are similar to those in preceding plates. Compare the following with the plates given in parentheses: *a-f* (12, 32) ; *j-o* (19-22) ; *q* (26) ; *r* (12).

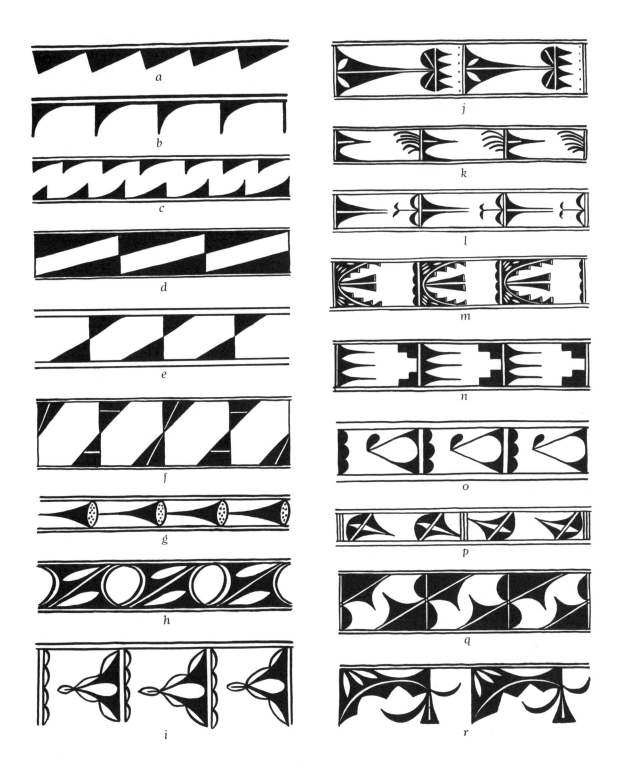

PLATE 43

113

Plate 44. Miscellaneous designs. In this miscellaneous group are several figures which may be classified with those in preceding plates. The arrangement in *a* is a modification of plate 19, *a*; and *c* is an elongate variant of the symmetrical forms in plate 56. Compare also the following figures with those in plates indicated in parentheses: *g* (21); *h* (36); *j, o* (33); *k, l, m* (46). The design in *g*, taken from the ceremonial bowl in plate 1, *e*, is described under Symbolism (p. 32). Three other designs, *i, n,* and *o*, are derived from the pottery of Zuñi pueblo, as mentioned in page 38.

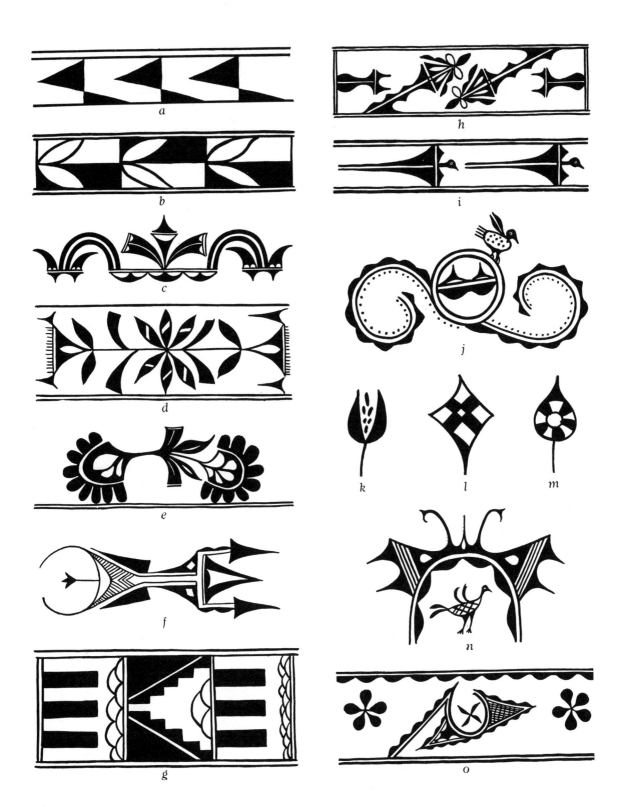

Labels within the figure (left to right, top to bottom): a, b, c, d, e, f, g, h, i, j, k, l, m, n, o

PLATE 44

115

Plate 45. Designs with both primary motifs and secondary spaces filled with black. These are generally believed to be the product of one potter, now deceased, who made frequent use of the device during a period of perhaps ten years prior to 1920. In eight of these, commonly used motifs are first painted in solid black, following which the open spaces are also painted black, leaving a narrow open space to separate the resulting secondary black spaces from the primary motifs (pl. 5, *f*). The system will be understood more readily by comparing it with that in similar designs by the same potter, in which the primary motifs are painted in red and the secondary spaces in black (pls. 5, *b*; 64, *d, h*). The primary motifs employed in several of this series are those shown in preceding plates. For example, compare *a* with the figures in plates 14 and 15; *b* with plate 16, *m*; *d* with plate 17, *j*; and *g* with plate 27, *g-j*. The others in plate 45 belong to no particular group, and give evidence of experiments with the new device.

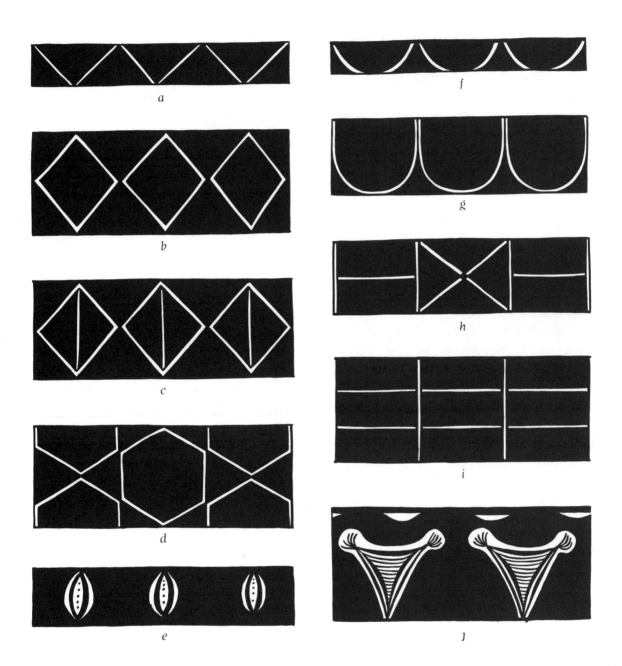

a

b

c

d

e

f

g

h

i

j

PLATE 45

117

Plates 46 and 47. Flowers used to embellish abstract designs, and in formal and informal arrangements of plants. Examples of the use of flowers and leaves, have appeared in many of the preceding plates. It is the amazing variety of these features that gives interest to the plant motifs of Santo Domingo. From information gleaned from the potters of other pueblos where flower motifs are occasionally used it seems likely that most, if not all, of the examples from Santo Domingo represent no specific form. The various features of petal, sepal, and possibly the disc of compound forms appear in endless combinations, and there are even examples of plants bearing two distinct forms of flower (pl. 71).

This fecundity of invention shows itself particularly in the later stages of pottery making when red came into general use, but even with the thirty-two examples in plates 46 and 47, considerable ingenuity is evident in the use of black alone. These have been grouped progressively in accordance with the number of petals or sepals used.

Realistic forms, either in outline or solid black, are rare; those in plates 46, *i,* and 47, *a, d, i,* and *p,* showing a minimum of elaboration.

Plate 46. Flowers. In one instance (*a*) the interpretation as flower might be questioned, though on the pot it appears at the end of a stalk bearing leaves of another form. There is also some doubt as to the meaning of three forms in plate 44 (*k, l, m*) which are used in the same position. Detached flower forms (*f, g*) are occasionally used in alternation with other units in the decorations of water jars of the type shown in plates 2, *f;* and 4, *b,* and *c.* The open spaces in petals or sepals are consistent with ornamentation of leaves in plates 48-52, and of feathers in plates 59, *c,* and 61, *f.* The use of dots within the petals of *f* and *h,* and outside the entire flower, as in *d, l,* and *m,* is purely decorative, but in *p* they may indicate seeds in the head of a composite form.

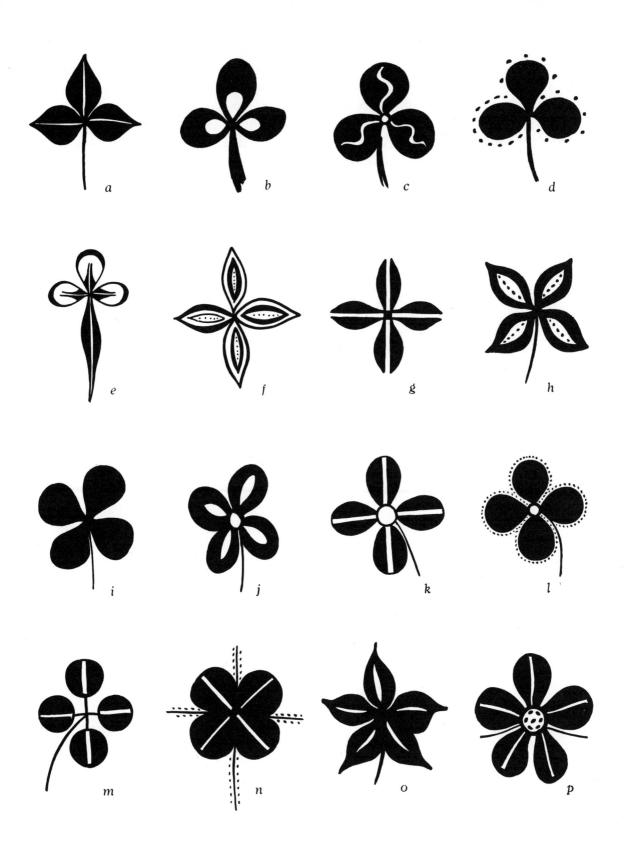

a b c d

e f g h

i j k l

m n o p

PLATE 46

119

Plate 47. Flowers. The flowers of plate 47 include those with five, six, eight, and ten petals or sepals, also *i* and *j* with the unusual numbers, seven and nine. In *h* and *l* two forms alternate, possibly as petals and sepals. Of these, four are placed obliquely in the form of an imperfect swastika. Realistic forms, either in outline or solid black, are rare; *a, d, i,* and *p* showing a minimum of conventional treatment. In *h* and *l* there is an alternation of two contrasting forms which may represent petals and sepals. Three pairs of decorative variants appear in the petals of *g*. Three detached forms (*g, l, n*) are used in the same manner as the two in plate 46 (*f, g*).

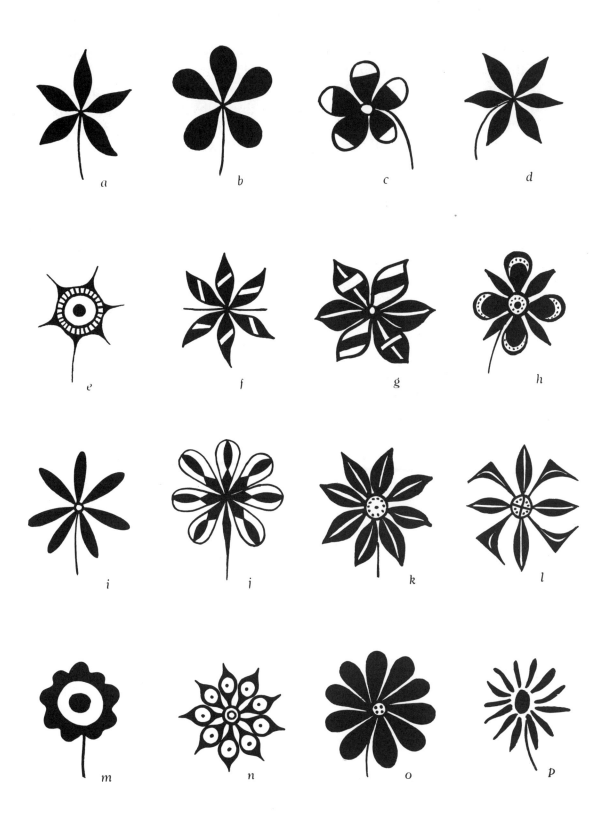

a

b

c

d

e

f

g

h

i

j

k

l

m

n

o

p

PLATE 47

121

Plates 48 to 51, inclusive. Leaf forms. It is surprising to find still greater variety in the leaf forms, since these are less complex in nature than even the simplest of the multiple petalled forms of flowers. The ninety-six examples in plates 48 to 51, inclusive, vary from simple lanceolate, obovate, and other natural forms, to many of an unrealistic type (pl. 50, l-*x*) developed by the use of decorative or symbolic elements upon the flattened ends of leaves similar to those of figures *a* to *f*, inclusive. In plate 51, four of these (*a-d*) are followed by six simple angular forms (*e-j*). Last in the group (*k-x*) are miscellaneous forms, mainly more realistic in contour.

It is notable that the realistic midrib appears most frequently in the more artificial forms, such as those in plate 50, and that, conversely, the greatest variety in decorative elements of artificial origin is found in the more realistic forms, such as those in plates 48 and 49. Many of these devices, particularly those in plate 49, will be recognized as elements commonly used in the preceding plates of band decorations.

Plate 48. Lanceolate leaf forms. Although these are quite leaf-like in outline, realism has been subordinated by the use of a great variety of decorative devices within the lanceolate forms.

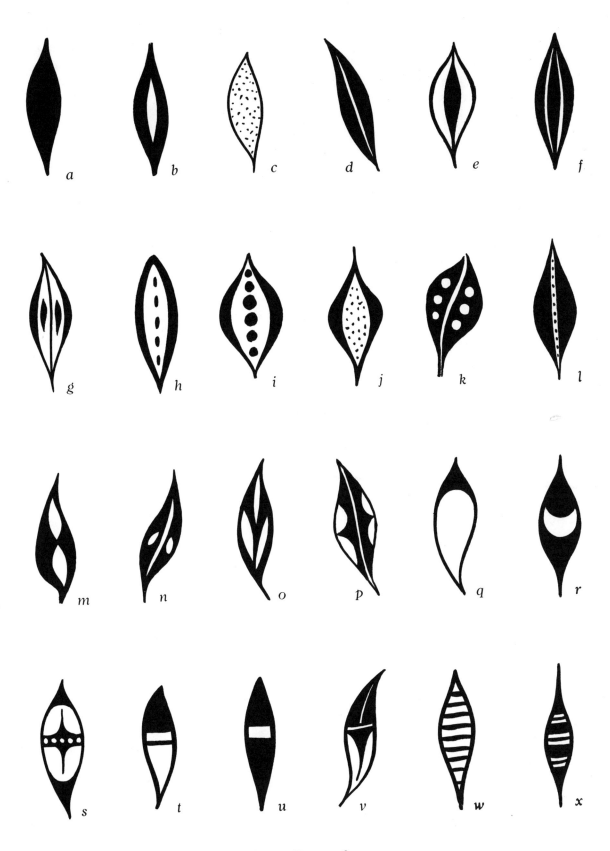

PLATE 48

123

Plate 49. Lanceolate and obovate leaf forms. Still other decorative ideas are used in the lanceolate forms of plate 49. In the obovate forms appear devices commonly used in larger form in bands and panels, such as the zigzags in *q* and *t*, and the double coves in *r* and *t*.

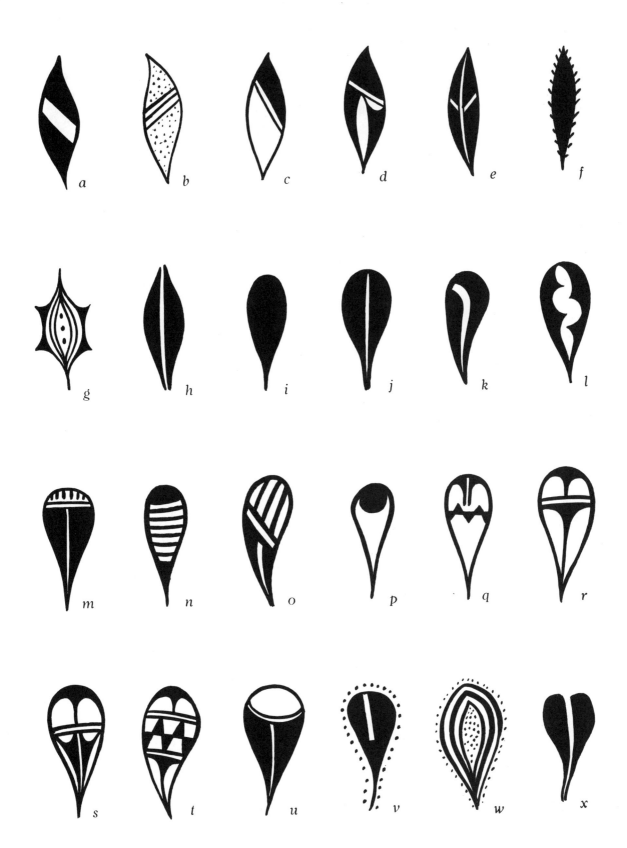

PLATE 49

Plate 50. Unrealistic leaf forms. Leaves with flattened ends are often used. To the simpler forms (*a-j*) are frequently added single, double, or multiple cloud forms as in *m, w,* and *x*. These may be attached to the leaf (*t, u*) or detached (*w, x*). The triangle (*p*) and double cove (*q, r, s*) are seldom used.

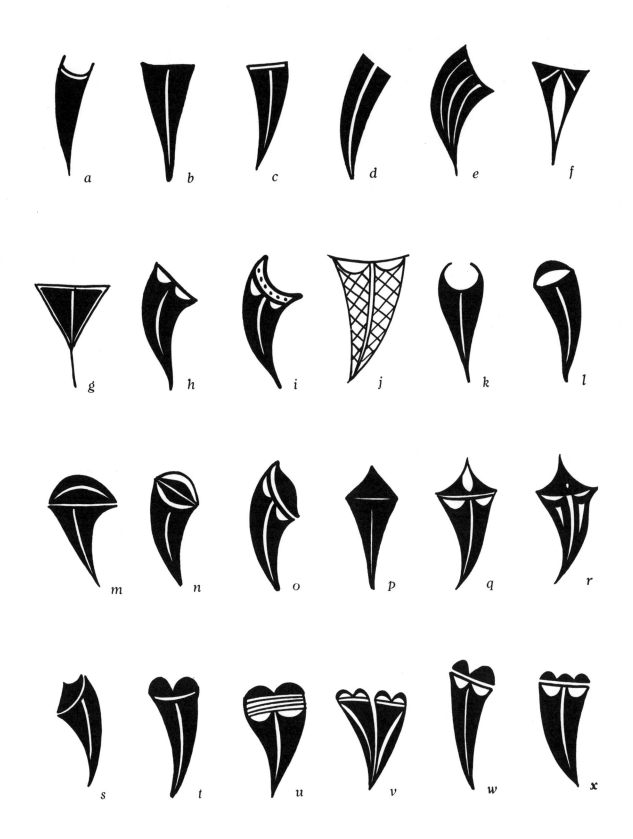

PLATE 50

127

Plate 51. Miscellaneous leaf forms. Four forms (*a-d*) are related to those in plate 50. Included among the remaining figures are some of more rigid geometric form (*e-j*). Others with unusually realistic contours (*k, p-s, v*) are the only examples of their kind obtained through many years of collecting. On the other hand many of the more artificial forms in plate 50 have been in common use since the earliest appearance of plant forms in Santo Domingo decoration.

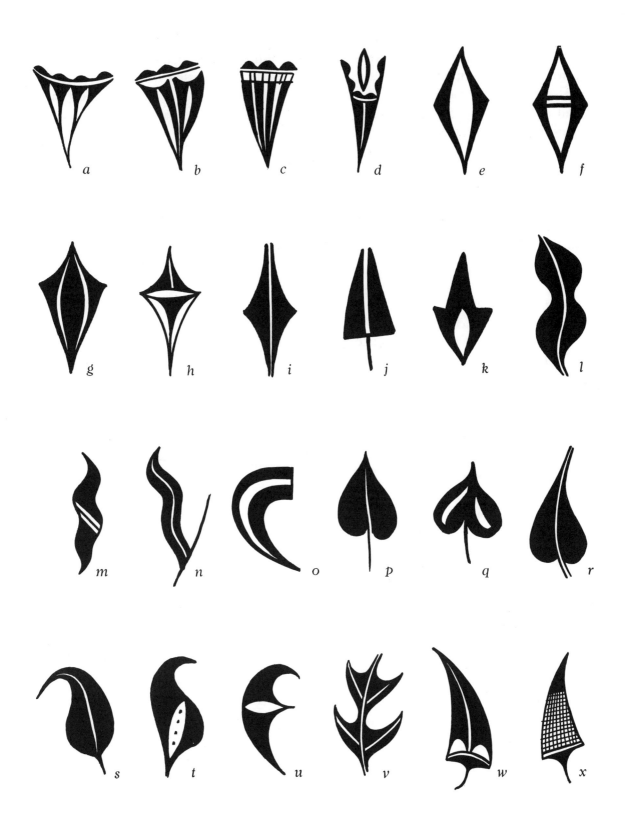

a *b* *c* *d* *e* *f*

g *h* *i* *j* *k* *l*

m *n* *o* *p* *q* *r*

s *t* *u* *v* *w* *x*

PLATE 51

Plate 52. Plant motifs in formal and informal arrangements. Plant forms as well as separate leaves and flowers, are not unknown in the earliest examples of Santo Domingo pottery, but they are much more freely used in various arrangements in the later period. The great variety of flowers and leaves has been indicated in plates 46 to 51, inclusive. These are used both as the natural parts of plant forms and as appendages of abstract designs. In the latter use more than 50 examples of leaves are found in the figures of plates 7 to 44, inclusive, but the use of flowers is limited to only a few. There are numerous examples of informal plant forms. Since the basic arrangement varies but little in all these, only two are shown (pl. 52, *a, g*). It is clear that the artists have not attempted a realistic representation of any particular plant of economic, medicinal, or esoteric importance in these designs, for in *g* three distinct leaf forms are used; and in *a,* if the long composite form at the left is taken as a leaf unit, an equal variety is found. There are innumerable examples of this naive combination of unlike leaf forms, such as those appearing in *c, e, h,* and *i,* but the use of two or more variants of flowers upon a plant is restricted to only a few examples similar to that in plate 71 in which many leaves and flowers are placed upon large plants.

The tendency to use plant motifs in horizontal arrangements, and usually within bands, is well indicated in all the figures of plate 52, excepting *a* and *g*.

a

g

b

h

c

i

d

j

e

k

f

l

PLATE 52

131

Plates 53 to 56, inclusive. Plant and other motifs in formal arrangements.
Plant forms, and other motifs closely allied to them in form and use, have given
a distinctive character to Santo Domingo decoration of the later period. The
thirty-two examples of formal, upright, bilaterally symmetrical arrangements
shown in plates 53 to 56, inclusive, are but a small part of the great number which
have been produced during the past thirty years by a few of the potters who have
developed this simple and striking type of decoration. Since continuous observa-
tion was impossible throughout this long period, the trend in the development of
the motif can only be conjectured. No examples appear upon the antique storage
jars of the Indian Arts Fund but it does not follow necessarily that the device was
not applied equally early upon water jars which have long since disappeared in
the course of daily use. The relative age of various available specimens bearing
this device cannot be determined. However, the occasional use of plant forms in
the earlier ware, and the predominance of the more complex abstract forms in
specimens of the past three decades, lead to the conclusion that the sequence as ar-
ranged for comparison in plates 53 to 56, inclusive, may well be in accordance with
the actual growth of the concept. These motifs, alternating with other units, usu-
ally smaller, are commonly placed in pairs upon jars in which there is no decora-
tive division between the red underbody and rim. Their relation to the banding
lines, and to the motifs which alternate with them, is best understood by reference
to plates 2, *f* and 4, *b* and *c*.

Plate 53. Conventionalized plant forms. In plate 53, all the figures have a
bilaterally even arrangement of details springing from a median stalk, and sug-
gesting a direct derivation from such more realistic plant forms as those in *a* and *e*.
In four figures (*a, c, d, g*) the motif stands upon the lower banding line. In the
others, it is not attached to the base.

a

b

c

d

e

f

g

h

PLATE 53

133

Plates 54 to 56, inclusive. Detached bilaterally symmetrical arrangements.
In these the device, instead of growing out of one stalk, is developed, with only
two exceptions, upon paired horizontal lines, from which depend minor details
of clouds, double coves, and other elements. Nearly all of these have a bilaterally
symmetrical arrangement of two wide stripes at each side, which may be modified
forms of leaves. An entirely different arrangement is used in plate 56, *g* and *h*.
All the designs in these three plates are detached from the banding lines.

a

e

b

f

c

g

d

h

PLATE 54

Plate 55. Detached bilaterally symmetrical arrangements, continued. The middle portion of most of the figures of plate 54 is composed largely of leaf forms. In plate 55 recognizable leaves are found in only two (*b, d*). In the others they are replaced by formal balanced motifs composed of details commonly used in bands.

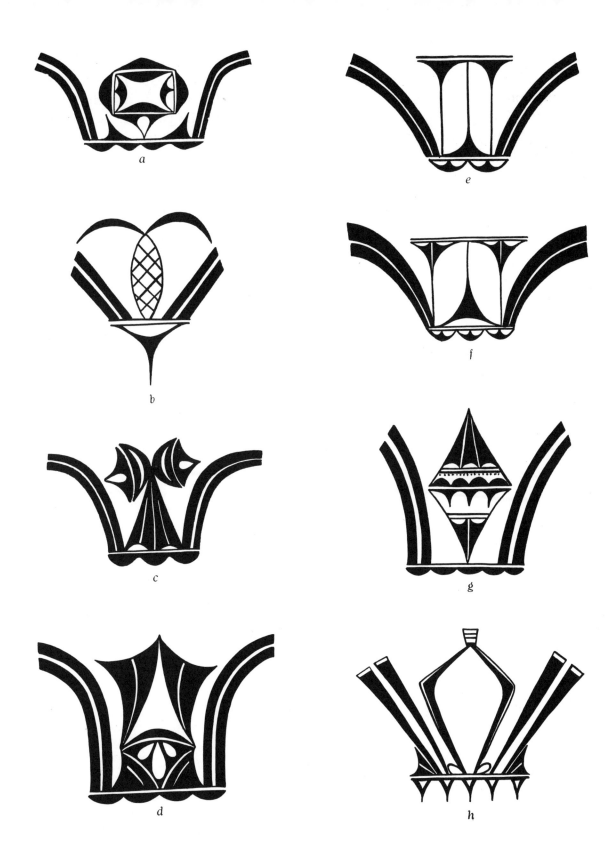

a

b

c

d

e

f

g

h

PLATE 55

137

Plate 56. Detached bilaterally symmetrical arrangements, continued. Recognizable leaf forms appear in several figures of this final group. Paired stripes, possibly modified leaf forms, are used in only three (*a, b, f*). A detached cloud symbol is placed at the end of each pair in *b*. In *a* and *f* the pairs of stripes terminate in motifs partly attached. A single heavy stripe is substituted in *e*. Figures *c, d, g,* and *h* show the least conformity with the more commonly used arrangements in plates 54 and 55. The balanced arrangement in *d*, resembling the wings of a butterfly, is sometimes called by that name.

a

e

b

f

c

g

d

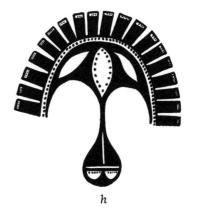

h

PLATE 56

Plates 57 to 62, inclusive. Birds. So frequently used in the pottery decoration of many other pueblos during the past century or more, the bird had but little favor at Santo Domingo during the long period in which black was the only decorative medium. It has received more attention during the past thirty years, and particularly in the decoration of jars on which there is no separation of neck and body by banding lines. There is no evidence of a gradual evolution from realistic to conventional forms. On the contrary, the earliest specimens show a considerable stylization consistent with the general design system of that period. Therefore in grouping the figures in the six plates, 57 to 62, inclusive, it must be understood that the more realistic body forms in plate 57 occur on both early and late pottery, and that many of the conventionalized types in the succeeding plates are of a comparatively early period.

Conforming with the usual practice in the decorative art of other pueblos, the bird figures face to the right, with but one exception (pl. 59, *d*). Throughout the series the parted mandibles predominate in the representation of the beak. The stylized eye, consisting of a dot within a circle, is quite like that of typical birds of other pueblos. Head plumes are rarely used. The fairly realistic wings shown in plate 57, *a* are unusual. In *c*, the three black stripes may represent individual feathers rather than wings. Various other devices are used as wings. The most curious of these are the plant forms in plates 60, *d*, and 62, *a* and *c*. Wings have been omitted from 14 of the 33 bird figures in these plates.

The arrangement of tail feathers is equally varied. In many specimens, such as plates 57, *f*, and 61, *b*, *c*, and *e*, they resemble leaves; while in others, such as plates 59, *e*, and 61, *f*, they might be mistaken for flowers if disassociated from the bird. The form of tail used in two (pl. 60, *c*, *e*) and the decorative, or perhaps symbolic, details in the bodies of these two are distinctly Santo Domingo in origin and use. Three figures (pl. 61, *a*, *d*, *e*) are from the interior of one bowl and are included to show the possible variation in the work of one artist. In one (*d*) the dots below the beak are interpreted as primitive symbols of sound. At least a semblance of realism is maintained in the body forms throughout the series, with one exception (pl. 62, *c*). Only rarely is the bird subordinated by association with larger motifs. However, in two examples (pl. 44, *j*, *n*) they are comparatively small. The repetition of only one portion of a bird in formal band decoration such as that in plate 11, *i*, is unique.

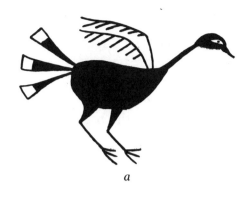

a

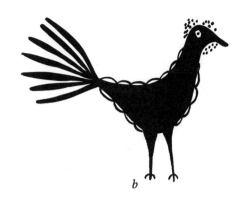

b

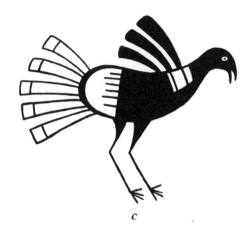

c

d

e

f

PLATE 57

Plate 58. Birds. The "D" shaped space within the bodies of four figures (*a, c, e, f*) and the detached wing and crest of the latter are derived from the bird commonly used by the potters of Acoma. The flower in the breast of *c* is unique in the decoration of this ware. Of the thirty-three birds shown in plates 57 to 62, only three rest on a base line (pls. 58, *b, e,* and 61, *b*). In plate 60, *b* one clutches the stem of a plant, and the feet of another, plate 60, *d,* touch the banding line. Other features of these figures in plate 58 are discussed in the introductory description of plates 57 to 62, inclusive.

a

b

c

d

e

f

PLATE 58

Plate 59. Birds. The only example of a bird drawn to face the left (*d*) is one of a pair from the interior of a bowl (pl. 7, *f*). The legs, erased by wear, have been restored in *d*. Other features of these figures are discussed in the introductory description of plates 57 to 62, inclusive.

a

b

c

d

e

f

PLATE 59

Plate 60. Birds. The placement of a bird on a twig (*b*) is commonly used at Acoma, and less frequently at Tsia. Figure *d,* sketched from a storage jar in use in the pueblo in 1910, is unique in many respects. Other features of the figures in plate 60 are discussed in the introductory description of plates 57 to 62, inclusive.

a

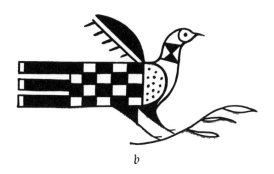

b

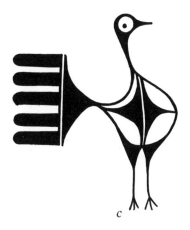

c

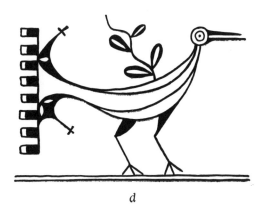

d

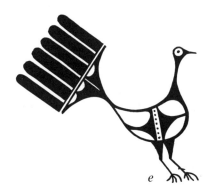

e

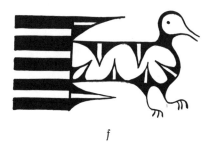

f

PLATE 60

Plate 61. Birds. The bulbous device shown in plate 34 appears between the body and tail in *c*. Three figures (*a, d, e*) are from the interior of one bowl and are included to show the variations possible in the work of one artist. In one (*d*) the dots below the beak are interpreted as primitive symbols of sound. Certain features of the other figures are discussed in the introductory description of plates 57 to 62, inclusive.

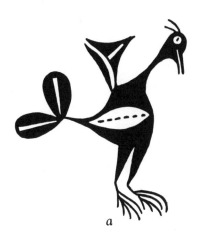

a

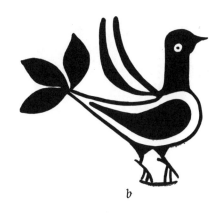

b

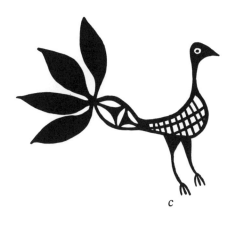

c

d

e

f

Plate 61

149

Plate 62. Birds. Features of figures *a* and *c* are discussed in the introductory description of plates 57 to 62, inclusive. In *e* the two leaf-like appendages to the head are evidently intended as wings. This unnatural position of wings appears also in plate 58, *e*.

Mammals. Included with the birds mentioned above are three animal figures (pl. 62, *b, d, f*). These are quite unusual in Santo Domingo art. Like the figures of birds, these also face to the right. Figure *b* presumably represents a mountain sheep, though the domestic goat may be intended. The horns of *d* resemble those of the pronghorn antelope. Figure *f* occurs in the exterior decoration of the same bowl. The two are part of the group shown in plate 4, *a*. Examples of the human figure are exceedingly rare in pueblo pottery decoration of the post-Spanish period, and there is no known instance of its use in Santo Domingo art.

a

b

c

d

e

f

PLATE 62

BLACK-ON-RED WARE

From comparatively early times, a small quantity of red ware seems to have been made by a few of the Santo Domingo potters. Not more than ten specimens have been found during the course of this study. Most of these give evidence of considerable age, though two in the collection of the Indian Arts Fund are known to have been made by one potter as late as 1920.

The forms of these few known specimens of bowls and jars are identical with those of Black-on-cream ware. The red clay slip is apparently mixed with a small proportion of cream slip, for in all specimens the tone of the decorated zone is lighter than that of the red underbody. In one specimen (pl. 5, *a*) the slip of the decorated zone is more orange than red, produced possibly by a mixture of native yellow ocher with the red clay. A typical bowl and jar are figured in plate 4, and ten distinctive designs are given in plate 63. These, like the figures in the preceding plates, average between one-third and one-fifth natural size. While not one is identical with any of those in the preceding plates of Black-on-cream ware designs, yet in general there is a marked resemblance between the decorative treatment of the two wares, as may be seen by comparing the following figures with those in the plates indicated in parentheses: *a* (pl. 16); *c, f, h* (pl. 13); *e* (pl. 24); *g* (pl. 32); *j* (pl. 17). Two distinctive designs appear in *d* and *i*.

PLATE 63

153

BLACK-AND-RED-ON-CREAM WARE[1]

Red, as an added decorative element in Santo Domingo pottery, was introduced in comparatively recent times, and has been used largely in providing a more attractive ware for the tourist market.

The pottery forms made for actual use in the pueblo are identical with those of black-on-cream ware (pl. 5, *d, e, g, h*), but the greater part of the production consists of small pieces in a variety of shapes which have but little practical use. A group of these is shown in plate 6. The painting of the black designs is identical with that of the Black-on-cream ware. The red is a native ocher ground into a paste which is then thinned with water to the proper consistency for use with the brush. That the ocher is applied after the black design has been painted with guaco is revealed in nearly every specimen by the careless overlapping of the black by the red.

To have recorded fully the variants used in the decoration of the great quantity of ware of this type produced during the past twenty years would have required frequent visits to the pueblo and to the shops of numerous dealers who have sold it. Since this has been impossible, a record has been kept of only the readily available variations in elements of design and of the characteristic arrangements of these in so far as they are affected by the use of an additional color.

Red was first applied in plant and bird motifs, which had been used but rarely in the decoration of the older Black-on-cream ware. There is some reason to believe that these more graphic motifs in black and red were evolved by the Santo Domingo artists through their familiarity with the pottery of their Keresan kindred at the pueblo of Tsia, which is especially rich in plant and bird designs. But whatever may have prompted the innovation, the black and red motifs of Santo Domingo are distinctive creations unlike those of Tsia or any other pueblo.

USE OF RED

Red is commonly used as a filler in spaces previously outlined with black (fig. 34, *a*) and separated from large black spaces by paired black lines (fig. 34, *b*). So familiar is this device that one is apt to overestimate its occurrence in the decoration of Santo Domingo. This method is used in approximately 60 per cent of the 195 figures in plates 64 to 79, inclusive, while in another 5 per cent it appears in combination with some other use of red in the same design. It must be remembered, however, that the figures were chosen during the past fifteen years for variety in subject, form, and decorative treatment. It is probable therefore that a tabulation of specimens taken at random would show a higher percentage of the predominating types *a* and *b*.

The various other means of using red with black are shown in figure 34, *c* to *l*, inclusive, in which rectangular spaces have been used for comparison. These, given in order according to the frequency with which they appear in the plates, are:

[1] Since 1936, known as Polychrome Ware. See p. 6.

(a) Red, outlined with black.
(b) Red, outlined with black, and separated from black space by a narrow open space.
(c) Red, not outlined.
(d) Red, outlined with, and adjoining black.
(e) Red within black.
(f) Red, separated from black outline by open space.
(g) Red dots within black outline.
(h) Row of red dots within black outline.
(i) Red dots around black space.
(j) Red, outlined with black, but not completely filling space.
(k) Red, outlined with black, and surrounding black space.
(l) Red outline, separated from black by open space.

FIG. 34—Uses of red with black.

POLISHED WARES

Four other types of pottery, recently introduced at Santo Domingo, are imitations of polished wares of the Tewa pueblos of Santa Clara and San Ildefonso. This innovation is attributable to the activity of one accomplished potter, a native of Santa Clara, who has lived at Santo Domingo for more than thirty years. Having spent some twelve years in Indian schools, she had not learned the potter's craft before she settled in her new home, where she picked up the rudiments without any instruction from her neighbors. For many years she followed the traditional types of Santo Domingo, and it was not until about 1925 that she began her experiments with plain polished red and polished black wares of the Santa Clara type. In more recent years she has produced a successful imitation of modern San Ildefonso wares: one with matte red on polished red, and the other the more popular matte black on polished black. The technique of each of these polished ware types is now commonly known and used at Santo Domingo, though the product is far from comparable in form and finish with the best produced in the Tewa pueblos. The forms differ considerably from those of the older types of Santo Domingo pottery, for they are made almost exclusively to supply the tourist demand for small pieces in many fanciful shapes (pl. 6).

POLISHED-RED, AND POLISHED-BLACK WARES

TECHNOLOGY—The clay, temper, and the process of modeling are identical with those used in the production of Black-on-cream ware. The slip is a smooth red clay which is applied in one or more thin coats. While the surface is still damp, the clay slip is given a high polish by rubbing with a smooth pebble of jasper or black quartz. In firing, the polished red surface turns to a slightly deeper red. Care must be taken to prevent close contact of burning dung cakes which would cause black smudged spots upon the red surface. If Polished-black ware is desired, the potter smudges the red ware as soon as the firing is completed, and without disturbing it in the kiln, by smothering the fire with straw or chaff thrown over the kiln heap. Occasional flames are extinguished by covering with more straw and chaff. By this means a dense smoke is produced, which turns the polished red ware to a rich black.

The firing is usually insufficient and consequently the pottery is soft and liable to disintegrate if saturated with moisture. Even if fired sufficiently to hold water, it is unsatisfactory in every day domestic use as the surface is affected by the seepage and evaporation of water, which corrodes the smooth polished slip.

POLISHED-RED, AND POLISHED-BLACK WARES, WITH MATTE DECORATION

TECHNOLOGY—To produce the San Ildefonso types of ware with matte decoration upon a polished surface, the entire surface of the unfired pot is polished as if it were to be left undecorated. Upon this the artist paints the matte decoration

with a fine greyish clayey substance, ground in *guaco* paint, the *guaco* serving as a flux to keep the matte surface from rubbing off before it is fired. If the pottery is not smudged in firing, the decoration will be light matte red upon the polished red surface. By smudging, a greyish black matte decoration is produced on a polished black surface. The ware can usually be distinguished from that of the Tewa pueblos by the rusty, brownish tone of the matte surface.

DECORATION—The decorative motifs are chosen from those more commonly used on the Black-on-cream ware. These include both the simpler geometric and other abstract motifs within bands, and arrangements of plant forms (pl. 6).

CONCLUSIONS

This study of Santo Domingo pottery has led to the inclusion of a far greater mass of data than was foreseen at the outset of the project in 1920. Thus more than 1000 designs, including details, are now made available for study. Of these, fortunately, the greater part are from the old style Black-on-cream ware which, persisting for more than a century, still shows scarcely a trace of outside influence in form or decoration.

Of the several objectives in view at the outset, it is clear that none has been fully attained. It was hoped that antique specimens might be forthcoming, to reveal a transitional stage between one or more of the late pre-Spanish pottery types and the earliest known phase of Santo Domingo Black-on-cream ware. But neither here nor at any other of the Rio Grande pueblos have any definite phases of such a sequence been established. If any Santo Domingo pottery of this little known period is included in the large collection from the excavations at Pecos,[1] it is not yet recognizable. A considerable quantity of Santo Domingo-like sherds appeared with the later Pecos material, but these are apparently of a period shortly preceding the abandonment of the pueblo in 1838, and quite characteristic of the type in use during the latter half of the nineteenth century.

A second objective, that of determining the decorative trend of Black-on-cream ware, is still largely unattained through the lack of definitely datable material of the past century or more. However the prevalence of a few simple geometric designs in specimens of evident antiquity and their persistence in modern use leads to the conclusion that these have long been the basic motifs of this ware and that the elaboration of these and other abstract motifs is largely the inevitable result of their continued use through a long period before plant and bird motifs came into favor.

Though a valid sequence may still be lacking for the non-graphic decorative elements of Black-on-cream ware, the designs as a whole show a marked tendency, as in other pueblos, toward adherence to a cultural pattern in the persistent use of old and familiar concepts, for in not one percent of the designs is there seen a use of

[1] Kidder 1931.

elements, motifs or arrangements which are clearly the result of conscious experiments with ideas having no precedent in Santo Domingo art. The borrowing of decorative devices of other pueblos has also been shown to be exceedingly rare.

Whether the adoption of the more graphic motifs was gradual or abrupt is yet undetermined, but the effects of this innovation were fully evident by 1900, and the new and more vital elements would doubtless have met with common favor in the pueblo, even without the added incentive of profit from sales, which has so altered the status of pottery making during the past twenty-five years.

Such innovations as those produced with variants of commonly used plant and bird motifs point here as in other pueblos to the marked influence of one potter of unusual attainments and vision, whose creations were received with favor and who set a new style to be followed by her less gifted co-workers.

This may eventually account for the lack of transitional styles both at Santo Domingo and at the other Rio Grande pueblos during that turbulent period of early post-Spanish times when a proficient and imaginative potter in each pueblo could have led her generation to the development of new art forms at intervals during which the usual conservative group control was in temporary abeyance.

New variants of the old motifs still appear in the decoration of Black-on-cream ware found in use at the pueblo. Perhaps a more considerable increase in such new devices might be noted, were it not for the fact that newer and more profitable wares provide a more satisfactory outlet for inventiveness which might otherwise have been confined to the old Black-on-cream ware. But countless repetitions of the old designs so typical of the ware of a half century ago are found in such numbers as to give still the impression as in former times, of an exceedingly simple and unvaried range in Santo Domingo decoration. The marked persistence of the old style ware is due mainly to its practical use in a community which has yielded less to outside influence than have most of the other Rio Grande pueblos. The more recent Black-and-red-on-cream ware is equally serviceable, at its best, and finds increasing favor among the housewives of the pueblo. But the making of great quantities of small trinkets for the tourist trade has led to careless work and only a few of the potters are producing larger and finer pieces suitable for every day domestic use.

As for the latest innovations in the production of the various types of polished red and black wares solely for the tourist trade, it is difficult to evaluate their stability and to determine the part they will play in the economic life of the pueblo.

The superior technique of one outsider has had no apparent effect on the quality of these wares which thus far have been of such inferior grade that they cannot compete with the more finished product of the Tewa pueblos. No genius appears at present among the Santo Domingo potters themselves to point the way toward a more exacting standard of excellence and to welcome competition among her fellow workers in maintaining it. Without such a communal effort to revitalize the craft and to put it upon a more sound economic basis, it may suffer the same

deplorable decline as the once preëminent ceramic art of Zuñi which has all but perished because of the inability of the potters to devise new types to compete with those of other pueblos whose wares are now sold throughout the southwest.

The continued use of typical old Santo Domingo designs in the decoration of these new wares shows their adaptability in new techniques and gives promise of their survival in the perpetuation of distinctive products as long as pottery making continues at the pueblo.

The appearance of such an exhaustive mass of decorative art as that in these pages will doubtless have some effect on the potters of Santo Domingo, for it is certain that few if any have ever visualized more than a fraction of the components of the decorative system in which they have had a part. That it will lead to literal copying is inevitable, but it may also point to a better realization of the many possibilities of a system which has held the interest of so many generations.

If the collection provides data of value for the future use of ethnologists and if the material here presented proves useful in comparative studies of the many factors entering into the development of primitive art, the writer will feel amply repaid for having carried the work through these many years, which have afforded an opportunity of saving so much of Santo Domingo decoration from oblivion.

Drawings of plates 64 to 79, inclusive. Plates 64 to 79, inclusive, show the use of red and black, as developed during the past thirty-five years by the potters of Santo Domingo. These have been arranged in conformity with the sequence of motifs used in the preceding plates of designs in black only. Like them, they average between one-third and one-fifth natural size.

Plate 64. Abstract designs. As previously stated, red was first used in the embellishment of plant and bird designs. The conservatism of the Santo Domingo artists is in no way more clearly revealed than in their adherence to the use of black alone in perpetuating the formal abstract designs of earlier times. Fifteen designs in plate 64, and a few in plate 72, constitute the entire lot of these abstract elements thus far observed in band and other simple extended arrangements, in which red has been used with black. Several in plate 64 show the possibilities of a distinctive style which may soon be lost to Santo Domingo since the present trend of the potters is toward the imitation of the more popular polished black ware of the Tewa pueblos. The influence of the originator of the Black-on-cream designs in plate 45 is apparent in three examples (pl. 64, *d, g, h*).

PLATE 64

Plates 65 to 68, inclusive. Flowers. The flowers in the four plates, 65 to 68, inclusive, show even greater variety than those in black alone. These, arranged progressively in groups of three, four, and more petalled forms, give but little evidence of a concern for realism on the part of the Santo Domingo potters. Only rarely are the petals painted in red, without the customary black outline. In this respect, the four-petalled forms in plate 65, *o* and *p,* and the five-petalled form of plate 66, *m,* are the most realistic. There is evidence of a deliberate choice of black for the petals of flowers in such examples as those in plates 65, *d*; 66, *d*; 67, *d-f,* and *h*; and 68, *a* and *o.* Alternate red and black petals of identical form and size appear in plates 67, *m;* 68, *e, m,* and *n.* Variations in the color details of petals of uniform shape occur in plates 66, *g*; 67, *o* and *p*; and 68, *d.* An alternation of petals unlike in size, form, and decoration, appears in plates 67, *n*; and 68, *f* to *l,* inclusive. It is possible, as noted under plates 46 and 47, that these may be intended to represent both petals and sepals, but the general trend of the entire group of plant forms from, rather than toward, realism leads to the belief that variety in decoration was the first consideration in their development. Such unreal forms as those in plates 65, *j*; 66, *i* and *j*; 67, *a*; and 68, *p,* show to what fanciful extremes the potters are tending in recent times.

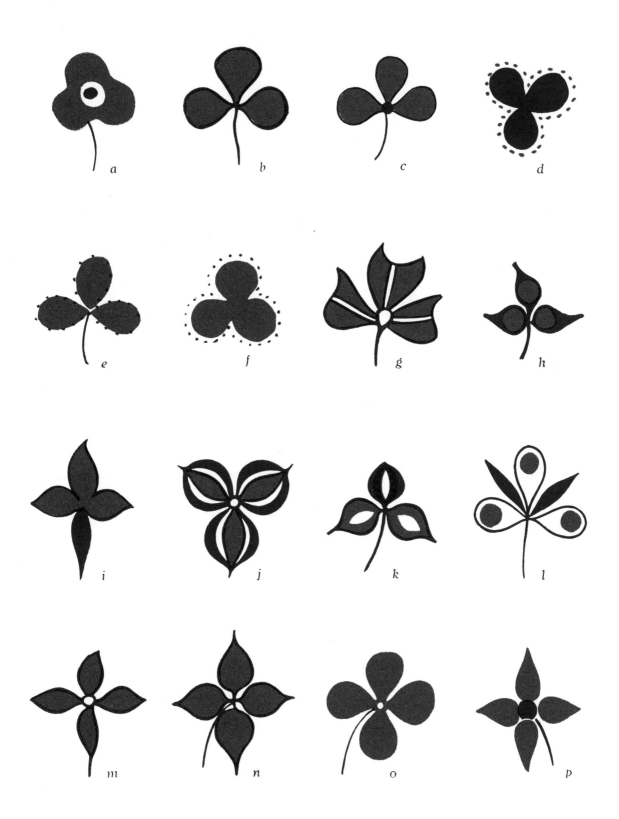

PLATE 65

Plate 66. Flowers. The use of black and red spaces adjoining without an open separating space is most pronounced in *d, e, h,* and *j,* while the most effective separation of the two is that in *f.*

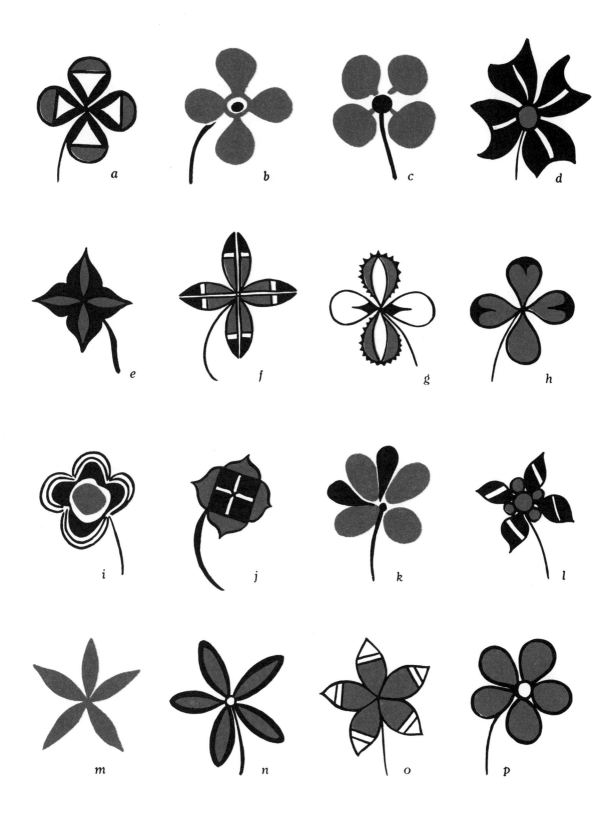

PLATE 66

Plate 67. Flowers. The greatest degree of originality is shown in *a*; in only one (*k*) is there a deliberate placing of black against red. The whirling effect in *m* is like that in plate 8, *k*.

PLATE 67

Plate 68. Flowers. It is doubtful whether the grouping of seven petals in *a* and *b* is intentional. A similar number is used in plate 47, *i* and *j*. In others the arrangement of eight develops naturally through the use of four of one form alternating with others of contrasting size or color, or both. In only two instances (*j, n*) are black and red spaces adjoined.

a b c d

e f g h

i j k l

m n o p

PLATE 68

Plates 69 and 70. Leaves. Leaf forms in black and red are grouped in plates 69 and 70. These forty-eight specimens, arranged in the same order as those in black only (plates 48-51) are not so numerous as the latter, for as is shown under the discussion of plate 72, the tendency is toward the use of black in leaves, in contrast with red in the petals of flowers. Only three are painted without black outlines (pl. 69, *b, d, e*). A few new devices appear in such figures as plate 69, *t, u,* and *w,* but as a whole the group shows no marked deviation from the forms in black only.

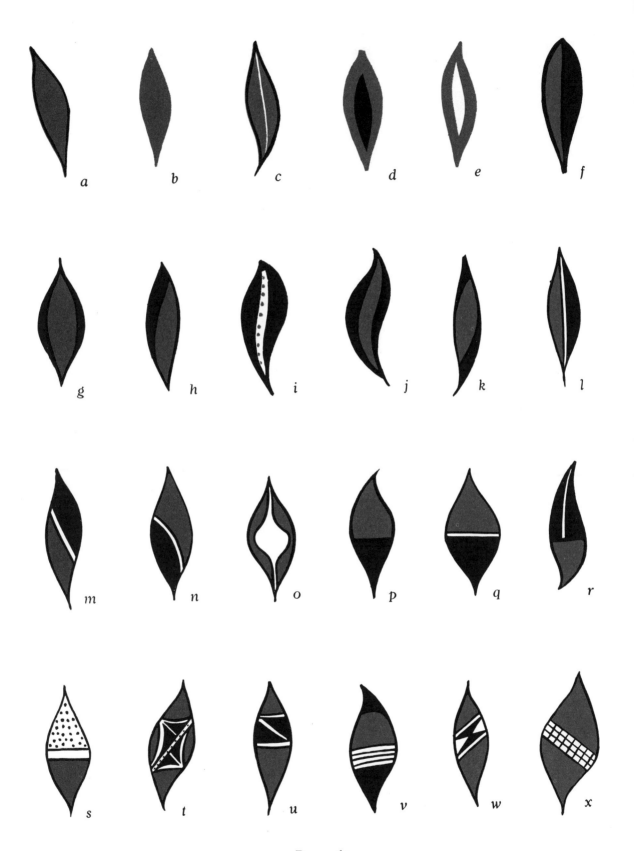

PLATE 69

Plate 70. Leaves. Most of these follow in form those in black only (pls. 48-51). Five forms (*t-x*) suggest attempts to deviate from the usual types.

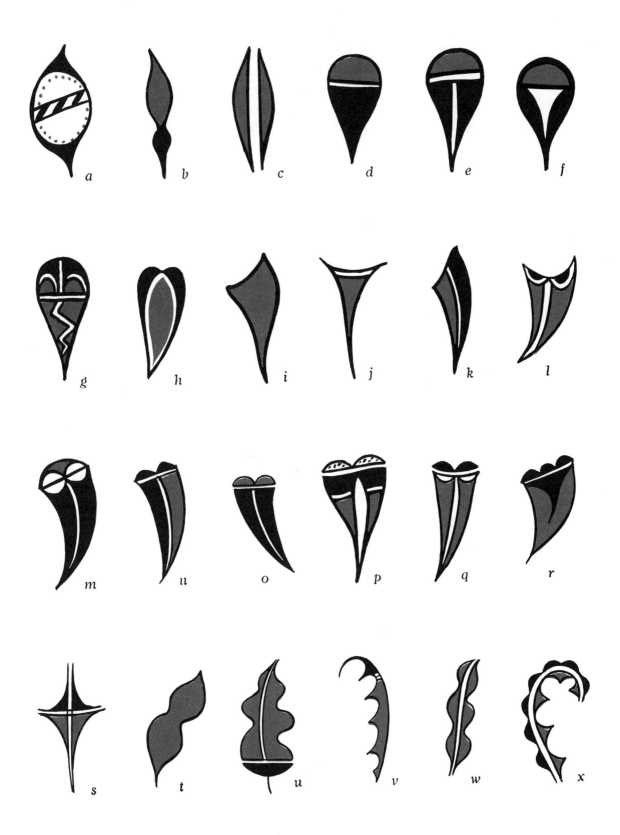

PLATE 70

Plate 71. Variety in flowers and leaves. A most informal use of plant forms containing black and red is that shown in plate 71. Here, at the left, a fairly balanced arrangement appears beside one with less balance, the two covering half the surface of a storage jar. Each bears three types of leaves and two types of flowers. In the plant at the left, the pair of devices containing dots may be interpreted as seed pods. At the extreme left, other detached leaf forms spring up from the red underbody (which is not shown). The flowers are rendered in red and black, and black alone, while the same freedom has been used in the coloring of the leaves.

PLATE 71

Plate 72. Plant and other motifs in horizontally extended arrangements. In plate 72 are eleven figures in which plant motifs are used horizontally, either with or without closely bordering lines. In six of these, flowers are recognizable. In most plant designs of both realistic and conventional form, red is naturally chosen for the petals of flowers, and for contrast the leaves are painted in black. Of the fifteen arrangements in plate 72, seven are static (*c-g, i, j*), seven are dynamic (*a, b, h, k-n*), and one (*o*) is mixed. In five of the figures flowers are recognizable, but in *f* the quadrate arrangements may represent either flowers or leaves. Among these *c* is an added example of the use of black in flower and red in leaves, noted under plates 65 to 68, and 71. The formal repetition of plant motifs in plate 72, *d, f,* and *j,* is a recent development giving evidence of the influence of an additional color in devising arrangements which had not been evolved in black alone. In *m,* a motif similar to those in plate 22 has been combined with plant elements probably intended for both flower and leaves. Figures *g, l, n,* and *o* contain no definite plant elements, except for the red leaf spaces set within the black in the angles of *n.* Included in this plate are two repetitions of simple detached elements in black and red, one of which (*g*) is quite unlike any of the forms in black only (pl. 9). The other (*o*) resembles some of the forms in plate 9, *a* to *e.*

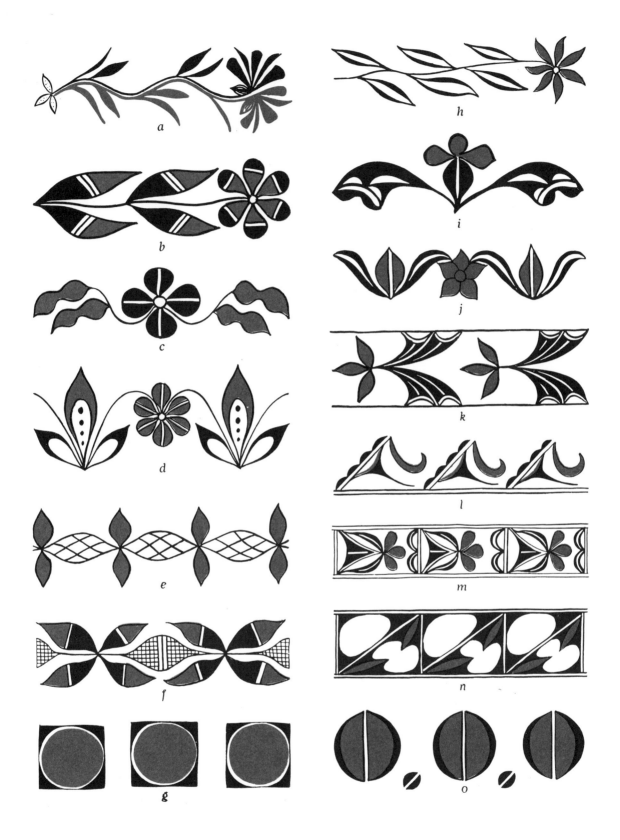

PLATE 72

Plate 73. Plant forms in formal arrangements. In plate 73 very little realism is retained in the formal balanced arrangement of plants. Several are extended horizontally without being confined closely within bands. Leaves are used only as minor accessories in *h*.

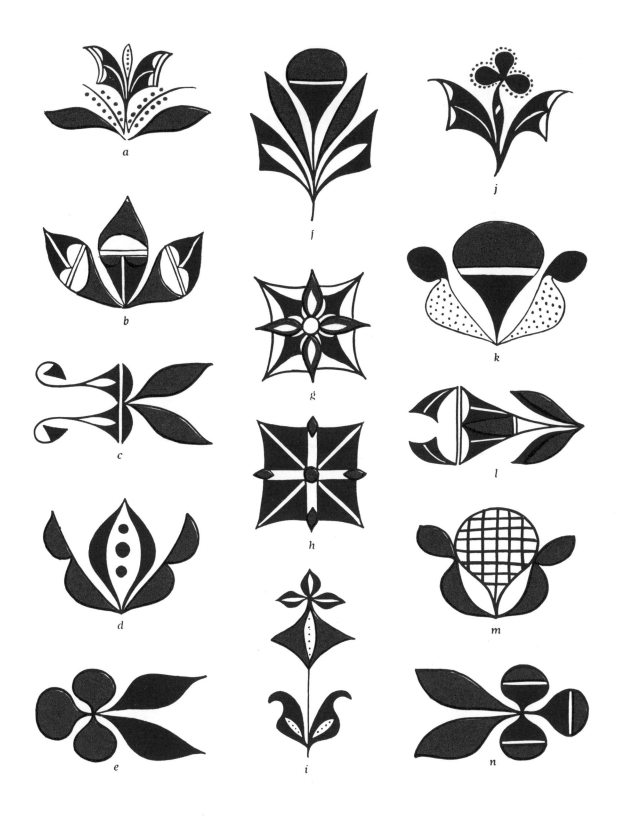

Plate 74. Detached bilaterally symmetrical arrangements of plants and other motifs. Plant and other motifs in bilaterally symmetrical arrangements similar to those in black only (pls. 53-56) are less in evidence in the ware with black and red decoration. Six examples are shown in plate 74; of these the most realistic forms of flower and leaf appear in *c*. In *g*, red dots are used to add color to what would otherwise be a simple black figure similar to those in plate 55. The two animal figures (*d, h*) are as rarely used as those in black only (pl. 62).

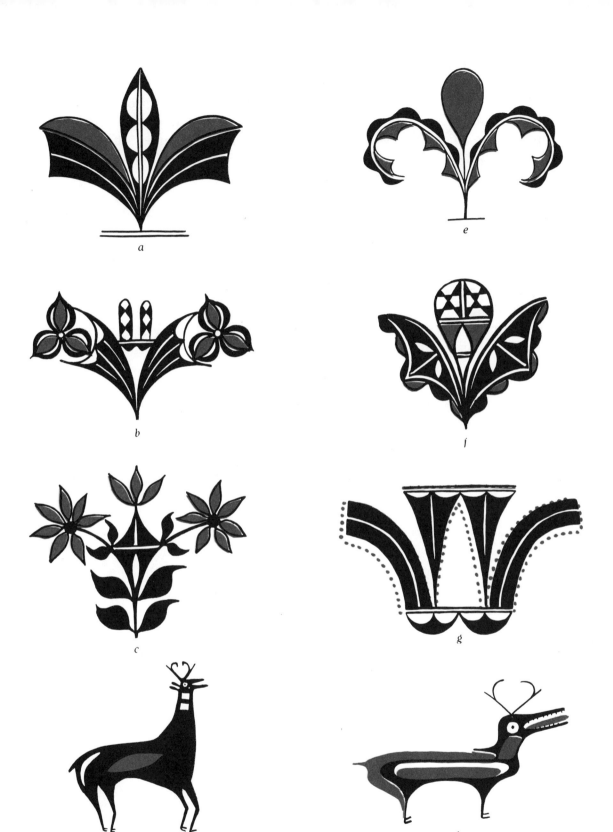

a

e

b

f

c

g

d

h

PLATE 74

Plates 75 to 79, inclusive. Birds. The use of red with black in the bird figures of plates 75 to 79, inclusive, has brought about some developments comparable with those in the preceding plates of plant motifs, where the association of two colors has added variety to form and arrangement of details. The wings are omitted in only five of the thirty figures. Throughout the series the variety of devices used singly and doubly to represent this feature is as great as that found in the forms with black only (pls. 57-62). In plate 75, four birds (*a-d*) have a conventional representation of feathered wings similar to those in plate 57, *a*. Two others (*e, f*) have a triple device unlike anything used for wings in plates 57 to 62, inclusive. In other figures, particularly in plates 76 and 77, are devices used singly for the wing. While these may have been intended as feathers, they are identical with the general form of leaves in plates 48 to 51, inclusive, in black; and in plates 69 and 70, where black and red are used. While there may be some doubt as to the meaning of these single devices, plants are clearly represented in plate 78, *b* and *d*, and more particularly in plate 79, *f*, where only the head and legs serve to identify the form as a bird. Like the birds in plates 57 to 62, inclusive, these, with few exceptions, face to the right.

a

b

c

d

e

f

PLATE 75

Plate 76. Birds. Four Figures (*b, c, e, f*) are by the same potter, and of approximately the same period, as is also *a* in plate 77. Her preference for adjoining of black and red spaces shows in four of the five figures.

PLATE 76

Plate 77. Birds. Figure *c* is unusual in that it faces left and has a flower motif in its body, resembling that in plate 58, *c*. The crest in *e* is a device often used at Tsia.

a

b

c

d

e

f

PLATE 77

Plate 78. Birds. The geometric device in *a* and the pair of coves in *d* are familiar motifs derived from the older Black-on-cream ware (pls. 17, 19). The detached wing of *e,* like that of plate 58, *f,* is a derivation from the typical bird of Acoma.

a

b

c

d

e

f

PLATE 78

Plate 79. Birds. The contrasting body forms of *a, d,* and *f,* and the varied features of wing, tail, and decorative treatment within the bodies of each of the six figures, give unusual variety to this concluding group.

PLATE 79

BIBLIOGRAPHY
Revised, 1952

PRE-SPANISH PERIOD

AMSDEN, CHARLES AVERY.
1931. Black-on-white Ware (in Kidder, 1931).
JEANCON, J. A.
1923. Excavations in the Chama Valley New Mexico. Bureau of American Ethnology, Bulletin 81, Washington, 1923.
KIDDER, ALFRED VINCENT.
1915. Pottery of the Pajarito Plateau and of some Adjacent Regions in New Mexico. Mem-oirs of the American Anthropological Association, vol. 2, part 6, pp. 407-462, Lancaster, 1915.
MERA, H. P.
1935. Ceramic Clues to the Prehistory of North Central New Mexico. Laboratory of Anthropology, Technical Series Bulletin no. 8, Santa Fe, 1935.

PRE- AND POST-SPANISH PERIOD

CHAPMAN, KENNETH M., AND ELLIS, BRUCE T.
1951. The Line Break, Problem Child of Pueblo Pottery. *El Palacio*, vol. 58, no. 9, Santa Fe, 1951.
KIDDER, ALFRED VINCENT
1924. An Introduction to the Study of Southwestern Archaeology. Papers of the Phillips Academy Southwestern Expedition, no. 1, Yale University Press, New Haven, 1924.
1931. The Pottery of Pecos, Vol. 1. Papers of the Phillips Academy Southwestern Expedition, no. 5, Yale University Press, New Haven, 1931.
MERA, H. P.
1937. The "Rain-Bird," a Study in Pueblo Design. Laboratory of Anthropology, Memoirs, vol. II, Santa Fe, 1937.

POST-SPANISH PERIOD

ALEXANDER, HARTLEY BURR.
1926. L'Art et la Philosophie des Indiens de l'Amerique du Nord. Editions Ernest Leroux, Paris, 1926.
BUNZEL, RUTH.
1929. The Pueblo Potter. Columbia University Press, New York, 1929.
CHAPMAN, KENNETH M.
1927. Post-Spanish Pueblo Pottery. Art and Archaeology, vol. xxiii, no. 5, pp. 207-213, Washington, 1927.
1933. Pueblo Indian Pottery, Part 1. C. Szwedzicki Nice, 1933.
1938. Pueblo Pottery of the Post-Spanish Period. (A revision of the 1927 item above). Laboratory of Anthropology, General Series, Bulletin no. 4, Santa Fe, 1938.
DOUGLAS, FREDERIC H.
1933. Modern Pueblo Pottery Types. Denver Art Museum, Department of Indian Art, Leaflets nos. 53-54, 1933.
1933-4. Indian Design Series. Denver Art Museum, Department of Indian Art, Denver, 1933-4.
GODDARD, PLINY EARLE.
1931. Pottery of the Southwestern Indians. The American Museum of Natural History, Guide Leaflet no. 73, New York, 1931.
GUTHE, CARL E.
1925. Pueblo Pottery Making. Papers of the Phillips Academy Southwestern Expedition, no. 2, Yale University Press, New Haven, 1925.
HARVEY, FRED, COMPANY.
1920. First Families of the Southwest. Kansas City, 1920.
KIDDER, ALFRED VINCENT.
1925. Introduction, pp. 1-15 (in Guthe, 1925).
MERA, H. P.
1939. Style Trends of Pueblo Pottery in the Rio Grande and Little Colorado Cultural Areas from the Sixteenth to the Nineteenth Century. Laboratory of Anthropology, Memoirs, vol. III, Santa Fe, 1939.
SAUNDERS, CHARLES FRANCIS.
1910. The Ceramic Art of the Pueblo Indians. International Studio, vol. xli, no. 163, pp. lxvi-lxx, New York, 1910.
SHEPARD, ANNA O.
1948. The Symmetry of Abstract Design with Special Reference to Ceramic Decoration. Carnegie Institution of Washington, Contributions to American Anthropology and History, no. 47, Washington, 1948.
SLOAN, JOHN, AND LaFARGE, OLIVER.
1931. Introduction to American Indian Art. The Exposition of Indian Tribal Arts, Inc., New York, 1931.
STEVENSON, JAMES.
1883. Illustrated Catalogue of the Collections obtained from the Indians of New Mexico and Arizona in 1879. Bureau of American Ethnology, Second Annual Report, pp. 307-422, Washington, 1883.